A PRACTICAL AND INFORMATIVE ARTISTS' GUIDE

To anyone interested in painting, water colours offer tremendous scope. From the traditional art of the Impressionists to the up-to-date Acrylic medium used by experimental painters today, Barbara Dorf discusses the wide variety of approaches incorporated in this versatile art form.

The fact that water colours are simple to use, quick-drying and comparatively cheap gives them a great advantage, and, for the novice and expert alike, the author describes in detail how the techniques for many styles of water colour painting, from landscapes and still life to portrait and abstract, can be developed. Extensive information is given on the materials used – the many types of brushes and paper – and for more adventurous work the use of inks and wax crayons is also covered.

This book is a guide in the truest sense, as it lays down no rigid rules, but instead offers practical advice that leaves readers free to experiment and express themselves with water colours in their own way. *Guide to Water Colour Painting* will be invaluable to anyone who wants to create pictures that are both beautiful and individual.

Guide to
Water Colour Painting

BARBARA DORF

SPHERE BOOKS LIMITED
30/32 Gray's Inn Road, London WC1X 8JL

First published in Great Britain by Pelham Books Ltd. 1972
Copyright © Barbara Dorf 1972
First Sphere Books edition 1973
Reprinted 1977

Set in Monotype Baskerville

Printed in Great Britain by
Hazell Watson & Viney Ltd
Aylesbury, Bucks

ACKNOWLEDGEMENTS

It is with great gratitude that I acknowledge the unfailing help and encouragement given to me by the following:

Mr. and Mrs. Tom Godris; Tom Rowney and the directors and technical staff at George Rowney and Co.; Dr. Rosamond Harley at Winsor and Newton; Olive Gabriel; Maurice Feild; Jeremy Maas; Patrick Procktor; Alan Ross; Ian Tregarthen Jenkin; Nigel Konstam and Ken Howard R.O.I.

CONTENTS

AN INTRODUCTION

Water colour is paint that can be mixed with water. This may seem so obvious as to be scarcely worth writing. However, when one thinks about water colour, one finds the term covers a wide number of ways of painting. There is the traditional water colour, using fine, old, hand-made paper. In this method, the colour is used without addition of white. Once white, or body colour, is added then water colour is known as Gouache, or in everyday practice as designer's and poster colour. The most versatile and up-to-date forms of painting using water as a medium are the new acrylic and polymer paints. Finally, there are the materials like wax crayon which completely reject water, and can be used because of this property.

This book will deal with all of these methods, though not by suggesting that one is better than another. Of course, one or another may be better for you. What suits each person to paint with is a matter of personal response to the medium. This means actually taking pleasure in the feel of a water-laden brush on paper. Or painting thick and thin masses with acrylic paint.

All aspects of water colour have one thing in common – and this is their great convenience. They are light, and you only need carry water to mix with the paint. Also, any kind of water colour can be used on paper and card of any description.

There have been many fine painters in water colour who never succeeded in using any other medium effectively. It is equally true that since the eighteenth century most great painters have painted in oils as well as water colours. These two mediums express different things and by no means contradict one another. It has to be admitted, however, that no painter in the past has used water colour with the same intensity as it is possible to achieve with oil. Traditional water colour expresses the fleeting, the atmospheric, and above all, light.

Water colour has been used in one form or another since

remotest antiquity. Generally, when we say traditional water colour we mean as it was used by the English water colour painters of the eighteenth century. Water colours then became exceedingly fashionable, both for collecting and for amateur artists. To such an extent, indeed, that the amateur water colour artists and their teachers were objects of satire and derision. For all that, amateur water colour painters have left us some charming and quite unselfconscious records of other times and customs. In particular, in this context one must mention the water colours of India by entirely amateur painters. These have now been published by the India Office. They are personal glimpses of India. Maybe because the artists were amateurs we have a feeling of complete authenticity. In some ways these little sketches tell one more about India than the imposing and skilful photographs by contemporary professional photographers. This then is one of the great advantages of water colour. It can record the fleeting moment and capture atmosphere – a delightful sight can be made permanent. Delight and charm are essential to a balanced vision of the universe.

There is also a serious side to water colour painting. This is in the beautiful botanical and ornithological studies which were painted in water colour. Water colour is a medium in which one can express the greatest detail and accurate observation, as well as the spontaneous. As water colour can express the effects of weather and natural history, it is scarcely surprising that the craft of water colour as an art form in its own right was developed in eighteenth-century Britain. Some of the early water colour painters like Francis Towne and Crome surprise and delight us to this day by the freshness and clarity of their work. During the nineteenth century some water colours became very elaborate, leading, in some critics' opinions, to a falling-off in quality. It was with the Impressionist painters and the twentieth century that a free technique came back into use with water colour. Paul Klee, who died in 1940, was one of the greatest painters in water colour who ever lived.

Acrylic and polymer paints have been in general use for about the last ten years or so. Most contemporary painters use them, and most modern experimental artists, because of their great variety and usefulness. It is with the use of polymer and acrylic that the first five chapters of this book will deal.

In general, handbooks on how to paint are read by people who do not have the time to go full time to art college, or went long enough ago to want to refresh their memories The whole idea is that people who do not have time to paint often, when they do, may take their paints and begin. Begin what, you may ask? The answer is: whatever *you* want to and never mind anything else. In spare times and holidays take your paints and record your own feelings. The greatest value of painting is to open your eyes to the world that is here, right in front of you. If the thought, to use an awful cliché, of 'mastering a technique' is daunting, then there are these marvellous new paints, polymer and acrylic. There is no complex technique, only accustoming your hand and mind to a few idiosyncracies of the paint. You need not even worry about board and canvas, you can paint on paper. As soon as you start painting you will find that your doubts will go away. If there is a difficulty in painting, it resolves itself by your going on working.

Never be afraid of your equipment; if you are working with acrylic paints, use large sheets of paper and plenty of colours. Being timid will not make it any easier, so be brave, and begin. Try, if you can, to paint fairly regularly, and do not wait to be inspired. Inspiration has an annoying quality: the more you wait for it the more it will elude you! Then, weeks and weeks could go by and you have nothing done. Start work and the mood to paint will come as you work. The more paintings you do, the more likely it is that you will do good ones. Often enough one's work goes through a bad patch, but this is nothing to worry about, it manures (as it were) the times when painting goes well!

This book is rightly called a 'guide', as distinct from hard and fast rules, and it is expected that rules may be rejected after they have been tried. Any reason to want to paint is probably a good one, so ignore that little voice within that tries to put you off! Most people are much more artistic than they think. You only have to look at back gardens from a train to see that. Though people who create nice back gardens might be taken aback to be thought of as, let alone told that they are, artistic! There have been times in the past when unknown folk have preserved the most vital tradition of art and craft. It certainly happened in the Dark Ages. It may be that unknown painters today in art clubs are preserving the very things we value in painting that

appear so conspicuously absent from established art. There is no doubt that the official art of the modern galleries is now no longer in the language of everyone. It is a private language. The first cause of art is communication. When you see, in an art club, somebody painting a picture to please somebody else, this is communication and this is normality.

Now here is a brief introduction to terms that will be used throughout the book:

COLOURS, COLD. A term used frequently in this book, and you will find it in most other painting manuals too. It means colours that, for some reason, make us think of cold, or coolness, when we look at them. Practically speaking a cold colour always contains some blue or black.

COLOURS, WARM OR HOT. The opposite of the above. Primarily red is associated with fire. Warm colours contain reds and oranges, and the red earth colours. Before the formal discovery of the technique of Impressionism, artists unconsciously used the same idea when they contrasted these colours. For instance, warm light has cold shadows and *vice versa*.

MEDIUM. What the particles of colour are ground in to hold the paint together. In the case of traditional water colour, it is gum arabic with a touch of glycerine, both these are soluble in water. In acrylic and polymer colours, the colours are bound in synthetic resins in an emulsion which, unless they have dried out on contact with air, are soluble in water.

SUPPORTS. What you actually paint on. In most cases throughout this book, the support will be various types of paper.

TONE VALUES. An expression used continually in all manuals on painting. It means the black, grey and whiteness of a colour: in fact, if a photograph were to be taken of the subject or the painting, the degree of black and white which each colour would come out. Some colours are tonally much darker than others; this is obvious.

VEHICLE. The liquid component of the paint. In effect, what you paint with. In the oil colours the medium is the same as the vehicle. The vehicle of all the paints dealt with in this book is of course, water.

WASH. A word you will very often find in water colour manuals. It means large quantities of water colour mixed

with much water, put full on the paper in broad strokes of the brush, or a sponge. Brushes are specially for washes, usually of the cheaper hairs to save expense. Skies are sometimes referred to as washes.

The following handbooks will be useful and interesting, and enlarge your knowledge of water colour. The first two are the old-fashioned classics of the traditional water colour technique. The problem with them is that many of the papers described are now, alas, out of production. Colours, too, are often impermanent or not made any more. However if you do want to imitate the palette of that first great classic water colour, *David Cox on Water Colour*, first published in 1813, the following is a fair guide. For prussian blue use monestial or Winsor blue. For gamboge use permanent or Winsor yellow. The earth colours are unchanged, but you should use a crimson instead of an impermanent carmine. It is, in fact, now difficult to track down David Cox's classic work. It is very expensive to buy, though any good reference library should have one. Technique apart it should be read for its wisdom and observation.

A. W. Rich, *Water Colour Painting*, Seely Service, 1927.
 Alas, out of print but it is still possible to find second hand copies.

The following are in print and readily available at any bookseller:
Rowland Hilder, *Starting With Water colour*, Studio Vista.
Colin Hayes, *The Technique of Water Colour Painting*, Batsford.
 The following titles concern acrylic and polymer:
Henry Pluckrose, *Introducing Acrylic Painting*, Batsford.
John Raynes, *Starting to Paint with Acrylics*, Studio Vista.
 A very excellent general handbook is:
Lynton Lamb, *Materials and Methods of Painting*, Oxford Paperbacks.
 Some recommended reading about water colour:
Koschatsky, *Watercolour*, Thames and Hudson.
(Also published by Thames and Hudson are histories of water colour in the eighteenth, nineteenth and twentieth centuries.)
Martin Hardie, *The History of British Water Colour*, published by Batsford in three volumes.

LARRY RIVERS, *Eight American Watercolour Painters*, Los Angeles Museum of Art.

The following handbooks are published by Rowney:
Water Colour is Fun by John Paddy Carstairs.
Cryla Colours – How To Use Them.

Winsor and Newton publish:
Gouache Painting with Designers Colours, by W. Mann A.R.C.A.

Blandford Press publish in paperback a series of books on water colour and drawing by Adrian Hill. They are very popular and useful.

BEGINNING WITH ACRYLIC AND POLYMER

Acrylic and polymer colours are becoming more and more popular. It is not at all difficult to see why. They are very convenient, clear, bright and permanent. They can be used very thickly and very thinly. With the exception of oil-based primings they can be used on any support. For the most simple and near to hand, one can list newspaper, cardboard, brown paper, hardboard, lining-papers and so on. Polymer and acrylic colours are light in weight. One of their greatest advantages which, as so often happens, can also be their main disadvantage, is that they are very quick drying. You cannot get round this; you have to adapt your technique to it. Once an acrylic or polymer painting has dried on a piece of paper you can roll the paper up, and the paint will not crack. As far as one can see, the acrylic and polymer colours are permanent and never crack, wrinkle or yellow.

Rowney manufacture a very excellent acrylic range, the name being 'Cryla'; there are thirty colours. Of the polymer colours, Rowney manufacture them as P.V.A. colours. Reeves make them too. Polymer and acrylic colours mix in water, of course. Once mixed and dried they *cannot* be dissolved again. The quality of acrylic and polymer is equal and excellent. The difference is in texture and use. Polymer paints are more fluid. They can be, and are, used to great effect in experimental collages. We will go into this in more detail later.

EQUIPMENT FOR POLYMER AND ACRYLIC

Supports, paper: Any paper. Brown paper, thin paper, thick paper, all kinds of cardboard. But be warned, if you use very inferior cheap paper, the paint itself may outlast the paper!

Supports, canvas etc. If you prefer a drum-like surface that responds to the touch of your brush, you could work on stretched canvas, linen or Terylene. Most often this is done for experimental work where the artist wants to construct a three-dimensional form.

Supports, wood etc. Wood is so inclined to warp that it is

not an ideal support. Hardboard is highly recommended, though you should use the smooth side. Sandpaper it if it is too slippery, but do *not* use the grained side. The texture is very insensitive, and not a bit like canvas, as some people think. The most popular kind of hardboard is Sundeala, with a soft surface. It has to be bought in bulk.

Priming: means a protective surface on the support. If the support is paper or board you do not need a priming unless you want one. A priming for acrylic or polymer must be acrylic or polymer too. On *no account* should a priming contain oil. If the support is canvas, Terylene or any woven fabric you need not use priming. Some painters deliberately use the paint on the woven fabric without priming, because if the paint is very watery it spreads on the canvas in rather interesting stains and patterns. Many painters prefer a primed surface. You can buy ready-made polymer or acrylic primers. Or, you can use at least two coats of very good quality emulsion paint.

Coloured Grounds: Ground is another word for priming that is used in some painting manuals. An acrylic priming can be tinted with any colour from a tube of paint, or a paint stainer. It means you have a middle tone ready-made before you begin. Most painters seem to prefer a warm ground to a cold one.

Brushes: You can use any kind of brushes for polymer and acrylic. Nylon brushes are manufactured for these paints and are excellent. With polymer and acrylic you do not find that the more expensive the brush the better is your response to the paint and support.

Care of brushes: While you are working with polymer and acrylics the brushes must be continually rinsed in water. The paint is so quick drying that once it is on the brush for too long, it can dry the brush solid. A brush so hardened can be cleaned by soaking overnight in methylated spirit. At all times, of course, prevention is better than cure.

Palettes: With some materials the paint will stick to the surface and cannot be removed. Glass and china can be cleaned of acrylic or polymer and so are suitable materials. If the paint has dried solidly on to glass or china, it can be peeled off when it is dry. Some manufacturers produce a special palette of plastic, which can be cleaned. A plastic palette is suitable for carrying about.

Media: Rowney, for their 'Cryla' colours, make different

16

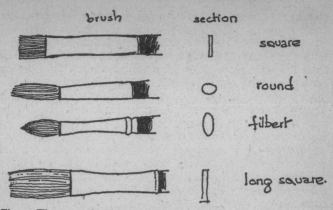

Fig. 1. These are the shapes of hog hair brushes in general use. The square brush is also made in nylon for polymer and acrylic. (The sables listed in Chapter 7 are very suitable for acrylic)

media. There is one to make a glossy surface, one for matt and another for glazing. Also, an additive medium for slowing up the process of drying. On no account whatever should you experiment with oils, varnishes, spirits, and turpentine with acrylic or polymer.

Remember: At all times when using polymer and acrylic you should take into account that the paint dries almost immediately.

If either acrylic or polymer are new to you, a very good way to find out about them is to make some experiments, more or less just to see what will happen. I have mentioned that polymer paints are very suitable for branches of painting that almost come within the definition of a craft. We will start with them, and have a look at collages. The word 'collage' comes from the French word to glue. Hence, one glues paper or other textures on to a surface. It is possible to make very agreeable collages without, in the conventional sense, being 'able to draw' (whatever that might mean). But you do have to have a good eye for colour, shape and texture. The first collages we will consider are those made of paper. The paper will be stuck on the surface of the support with the P.V.A. paint. Make sure that the support is strong enough to carry the weight of the paper stuck on to it.

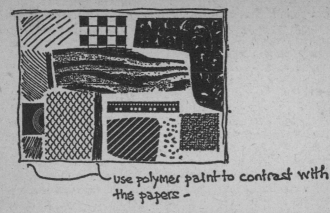

use polymer paint to contrast with the papers -

Fig. 2. Collage with many different kinds of paper stuck on with polymer

Many people who make collages enjoy the collecting of the different kinds of paper quite as much as the actual making. Naturally you do not need to go out and buy paper specially. You can start by just collecting scraps. You should look for texture, pattern, thickness and thinness. One could enumerate the kinds of paper indefinitely: wood grain, corrugated, gold, printed in unusual alphabets. Tissue paper especially is good – you can stick one layer on to another to

Fig. 3. This is using patterned paper 'literally'. Wood as wood, newspaper as a newspaper etc.

effect colours that contrast to the paint. There seem to be two basic approaches to collage with paper. One is using textures literally – supposing you had some wood grain paper, then you could use it for literally representing wood in the picture. You might paint the background blue so that you read sky, and so you go on. Then there is the other approach, of using the textures and patterns just for their own sake, to make a pleasing pattern. The paint should be used to contrast with the papers. Paint on the paper where it helps the whole design. Do see that your paper for collage is clean and does not look grubby, as this can be rather depressing. Once you are thinking of collages you will be surprised in what unusual places you will find suitable material. Years ago, some artists used to use old tram tickets! Remember, when you use tissue paper, to glue it very lightly with white P.V.A. polymer paint mixed in water. Anything thick or coloured will ruin it.

CONSTRUCTIONAL COLLAGES

To go on to something more adventurous with collages, polymer will stick more things than paper to a support, though of course, the heavier the materials you are sticking the stronger your support will have to be. Indeed, you are best advised to use hardboard. Polymer and P.V.A. paints will stick polystyrene cut in any shape; wire, string, plastic, wood, tin, pieces of machinery. There is even more fun collecting equipment and oddments. Naturally the heavier the thing you are sticking on the support, the thicker the paint should be. Probably, there can be no rules for this sort of painting. One is reminded of the statement by the poet-prophet of Cubism, Apollinaire: 'You can paint with whatever you please.' To give a surface the appearance of

Fig. 4 Relief construction

19

Fig. 5. Relief construction (*Side view*)

consistence you can paint over the whole area with polymer. Polymer paint can be mixed with sand, pumice powder, or fillers. Picasso said, 'I put all the things I like into my pictures. The things, so much the worse for them, have to put up with it!' It is pointless analysing whether this kind of experimental painting is better or worse than figurative. It originates from responding to the nature of materials, an instinct that is basic to most people. It means putting together textures, shapes and colours until you think they look 'right', or until they please you, and, one hopes, somebody else too! In relief construction you have also to consider the effect of the solid form. Consider contrasts of textures, like polystyrene and the kind of plastic that is used for containers and egg holders. If all the objects of a relief construction look incongruous, this can be overcome by painting the whole surface one colour like white, or even with a metallic paint. Once you have started to do these sort of constructions, you will be surprised at how it will open your eyes to seeing the possibilities of the most unexpected materials and objects.

From Ben Nicholson to Richard Smith painters have seen that relief and painting are very close, and indeed have no distinction. Richard Smith uses a wooden frame and canvas as support for his highly original paintings. The wooden frame must be constructed accurately, and the canvas, Terylene or nylon stretched carefully and evenly. Shoddy constructions are quite pointless. They really *do* look amateurish, a word that in general I try to avoid. When most people use the term 'amateurish' about a painting or art work, they never mean that the artist makes his living in some other way, for most artists do; they mean the artist has shown no respect for his materials, or the craft of his art.

The impact of three-dimensional paintings has a lot to do with scale. They seem to demand a largeness of scale. They certainly look better in large surroundings. Working on a very large scale there are times when you could well use

20

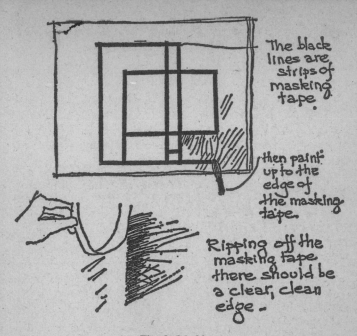

The black lines are strips of masking tape.

then paint up to the edge of the masking tape.

Ripping off the masking tape there should be a clear, clean edge.

Fig. 6. Masking

emulsion house paint providing it is of very good quality – and use decorators brushes too. Most artists use a stapling gun, rather than tacks, to fix canvas etc. on unusually shaped frames.

There are the abstract paintings that are, as one might say, straightforward painting – Not concerned with any other materials than the support and the paint. For the kind of abstract painting that is dependent on sharp clear edges, polymer and acrylic paints are exceptionally suitable. As acrylic paints tend to come in a larger range of colours I shall be dealing with them from now on. The usual method of acrylic for an absolutely straight edge is to put masking tape on the support, and rip it off when the paint has dried. The kind of abstract painting that depends on clear hard edges looks absolutely awful if the edges are in any way messy. This point was once raised with a student who then claimed that the messy edge was intended!

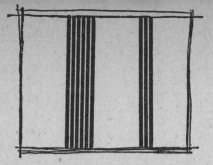

Fig. 7. The effectiveness of this sort of painting is on the clear, straight edges of the lines

In the contemporary situation, it seems one can dictate one's own terms for what painting is about, and one can have complete freedom. For all that, you can see that there are cases where you have to have some rules. In *optical* paintings these are very much dependent on extremely accurate workmanship. The fact that acrylic dries so quickly makes it ideal for clean, clear working.

Acrylic can be built up with a palette knife. Take care that, while you are mixing it on your palette, it does not dry on you! Indeed you may be advised to use the medium to slow drying. Acrylic can only be built up layer by layer, and there is not much opportunity for working into the paint once it is on the support. The great advantage of acrylic is that it will not crack or wrinkle. Once it is dry you can easily glaze over the top of the heaviest impasto, with delightful effect. You cannot, however, scrape acrylic down once a surface has dried. If you are building a very heavy impasto, theoretically you can do so on paper, though in terms of framing you are well advised to use a stronger support, like hardboard or well-stretched Terylene, nylon or canvas.

Then there is quite another approach to acrylic. You can use an absorbent canvas, Terylene or nylon support, and paint in very thin washes of diluted acrylic and water. This will spread on the canvas etc. in stains with soft indefinite edges, though you will find that in time the paint stains will saturate the support to make a priming and will no longer absorb the colour.

It is not very easy to make acrylic paint make marks that

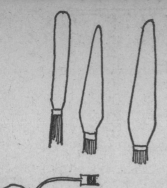

Palette knives can be used for painting, as well as cleaning the palette

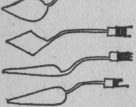

Painting knives are flexible, and finely ground.

In acrylic, you can paint on in thick slabs. Once it has dried you cannot scrape the paint down,

but you can glaze on top of it.

Fig. 8. Palette knives

are trial lines. This is very much easier in an oil-based paint, because it dries far more slowly.

The methods of using polymer (P.V.A. as it is called by Rowney) and acrylic paints have been categorised under the

Fig. 9. Thin paint on an unprimed canvas will spread into the grain of the canvas

different ways they can be used, but of course these ways can be used together in any painting you like. The separation is for convenience of introduction to them. Naturally, you could paint a very heavy impasto in polymer or acrylic and then make a collage on that. Quite apart from anything I have described there is always the method of painting a non-figurative painting, by just starting to paint. You start with a paint and a colour or a shape and see what the paint itself demands. Will you put a colour here? Or there? Will you glaze this passage? Are the tones too even or the density of

Fig. 10. Painting as the paint and colour itself suggests to you

the paint in one area distorting the picture space? Perhaps an area of colour is distorting the picture space. Stand back and look at the painting. A very good way of assessing a painting is to turn it upside down. If you really cannot see what is amiss, put it face to the wall and come to it later with a fresh eye.

Even if you do not feel drawn temperamentally to an abstract painting, it is worth trying one at some time, as all figurative painting contains some of the elements of abstraction – composition tonality, shape and rhythm, and many others.

Remember, with acrylic and polymer, the paint dries very quickly. It can even dry on the brush as you are working. Rinse your brushes continually to preserve them.

A list of contemporary painters using acrylic and polymer is formidable indeed! They were in common use in the United States before they reached this country. The new generation of painters using experimental media and polymers are widely represented in all our museums and galleries.

Some books for further study, then some painters:
NATALIE d'ARBELOFF, *An Artist's Workbook, Line Volume, Shape, Light,* Studio Vista.
H. PATTERSON AND R. GERRING, *Exploring with Paint,* Studio Vista.
JOHN RAYNES, *Starting to Paint with Acrylics,* Studio Vista.
H. PLUCKROSE, *Introducing Acrylic Painting,* Batsford.
Penguin are bringing out a series on modern painters; at the present both those published are painters in acrylic: Robyn Denny, Patrick Caulfield.
Rowney publications No. 32 *Cryla Colours – How to Use Them.*
More painters: Lichtenstein, Bridget Riley, Frank Stella, Richard Smith.

STILL LIFE IN ACRYLIC

Let us begin with figurative painting with acrylic. This implies more or less that you will be painting from things that you see. Or at any rate have a fairly clear idea of an image taken from the external world. I admit to a strong bias to starting with still life. A still life can be worked on indefinitely. It can be arranged with limited colours. You can study clear simple forms.

One could of course begin straight away with landscape or the figure, and if this is what you really want then by all means turn to the chapters about these subjects, and come back to this one later. The disadvantage of doing so is that landscapes and the figure are more complicated. If the first paintings you do go badly wrong this can be dreadfully discouraging. A basic training in still life is a very good way of learning to clarify your thoughts.

First your paints. As they dry so quickly, there is not a great deal of time to mix them, so to avoid the need of too much mixing, use more colours. This is controversial. Many painting manuals and teachers believe that the more colours you use the more confusing it can become. Of course, if you are struggling to manage twenty or so as a beginner it *will* be muddling. But everyone, or nearly everyone, responds to colour. So many beautiful colours are made – so why not use them? If the idea of many colours is worrying, then the first part of the chapter will deal with still life from a limited palette. Some painters worry that the more colours you have, the greater the expense. This is scarcely logical. It only means you use a bit less of lots more.

The following colours are all permanent:

White	Permanent yellow*
Lemon yellow	Yellow ochre
Cadmium orange	Bright green*
Vermilion hue	Monestial green
Permanent rose, or crimson	Venetian red
Permanent violet	Raw umber

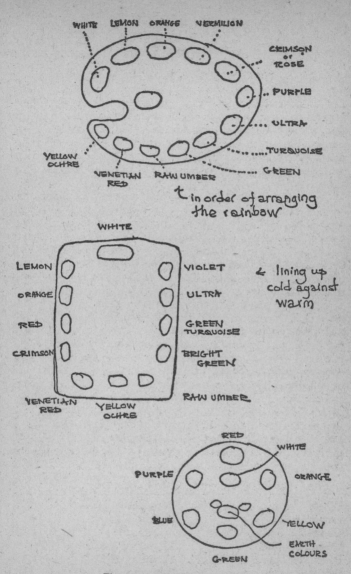

Fig. 11. Arranging your palette

Ultramarine	Burnt umber*
Cobalt blue*	Black*
Turquoise	

The colours you could reasonably omit are starred. Remember, it is tempting, on seeing any tube of colour, to want to squeeze out a big shiny slug of paint. This is a bad idea in acrylic, as, unless you are working very quickly indeed maybe with a palette knife, the paint will dry. A great advantage of acrylic is that it imposes economy on the user. When you have finished putting colour out, you *must* put the tops back on the colours. It is as well at all times to have a method for putting out your palette. Method with your equipment helps you clarify your thoughts. Fig. 11 shows you several ways of laying out a palette. Some artists like to go in order of the rainbow, others line up cold colours one side as against warm the other. To carry about, use a plastic palette; at home a glass one is very good.

Plenty of water, a palette knife, your support, and then you can begin. It probably need not be said that if you are painting on paper while it does not need to be stretched, it should be pinned down securely. Either with drawing pins or a stapling gun if you have one.

YOUR FIRST STILL LIFE

This I think should not contain anything like flowers or fruit that will rapidly 'go off'. It is a good idea to arrange one all in neutral colours, and in clear simple shapes (Fig. 12).

Now for composing the still life as you see it, to be a painting on your board. (Board is a convenient way of saying support, you could of course be using canvas or paper or Terylene etc.) You have some say in how the still life is arranged on the table or mantel shelf.

(1) You could arrange it like balance or a landscape, or figures, or – just leave them as they were.

(2) With plenty of paper and pencils available the problem is now of transferring the image that your eye sees on to the board. Your eye sees something quite clear in front of you. How then can you get your hand and paint to reproduce this image. Look carefully. A very good device is a view finder, as on a camera (Fig. 13). How much background? Draw that view. Too much background (Fig. 14)? Draw another view (Fig. 15). Is the drawing difficult? It

Fig. 12. Some very simple objects in dull cream, white and grey

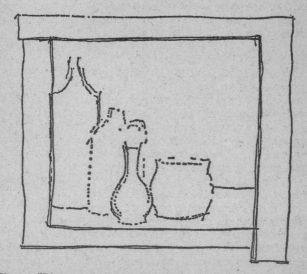

Fig. 13. Using two L shaped pieces of cardboard as a view finder

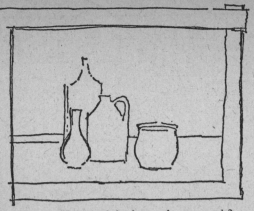

Fig. 14. How much background – too much?

Fig. 15. Another view

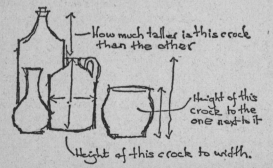

How much taller is this crock than the other

Height of this crock to the one next to it

Height of this crock to width.

Fig. 16. Outline the objects and measure the proportions and the painting will be well on its way

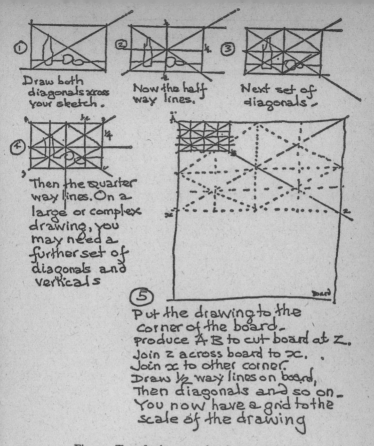

Fig. 17. Transferring your drawing to the board

need not be – an outline, round the objects and there you are. Measure proportions, width for height (Fig. 16). Try another view again. Take a look at your drawings, which one will you use for the painting. Having decided . . .

(3) Transfer drawing to your board. You can either do this by eye or by the perfectly simple method shown in Fig. 17.

(4) To begin painting. With plenty of water mix up any colour to paint in the outline. Some painters draw in with charcoal; please yourself but you might as well begin by

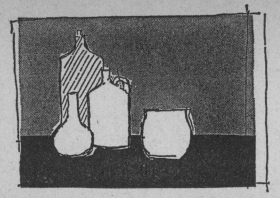

Fig. 18. Lay in main colour tone areas over *all* of the painting

painting straight away. Have your paint very well diluted.
Paint the outline in any colour you like. Most painters
favour a neutral colour like raw umber, though a blue is very
clear to see.

(5) Now a bit of thinking with your eyes. What is the
lightest colour and therefore the lightest tone? Having
decided that, in broad liquid brush strokes lay in the main
colour tone areas (Fig. 18). Put the brush into water as soon
as you have finished. Possibly the darkest areas are where the
shadow falls. See that this makes a good pattern (Fig. 19).
How can you make the objects look more solid? Check the
drawing with your paint. Are the lines correct? Repaint
the background until they are (Fig. 20). Now think about
grading the shadows (Figs. 21 and 22). Are there colours in
the shadows, or warmer than the light or colder, or a bit of
both? As the still life is in neutral colours, you will not see
many bright reflected colours in the shadows. Model the
gradations of tone and colour with thin liquid paint. You
will notice that acrylic is transparent, and each paint stroke
can be seen as in old tempera painting. This can and should
be used to great advantage. As you continue painting, build
up the paint thicker as you go. It is as well to start thin and
build up thick, as, in acrylic, you cannot scrape paint down
once it has dried.

(6) Stand back now and take a look at your painting.
Perhaps it is not as you expected – this always happens with
a beginner. Are there any areas unpainted? You should

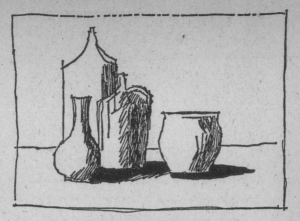

Fig. 19. Look for the patterns shadows make

Fig. 20. An object can be redrawn by altering its boundary by repainting the background

paint these over at once, as they distort all the tones and colours. When creating a still life, do always paint the whole of the picture. This is not as obvious as it sounds – it is very tempting in a still life to paint certain objects with loving care, and ignore the surrounds (Fig. 23). This will not work, since whatever you do to one part of the painting will affect the rest. Those glints of light on still life objects, which catch

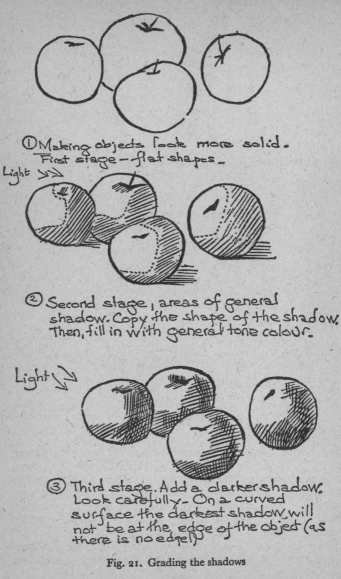

① Making objects look more solid.
 First stage — flat shapes.

Light ⟩⟩

② Second stage ; areas of general
 shadow. Copy the shape of the shadow.
 Then, fill in with general tone colour.

Light ⟩⟩

③ Third stage. Add a darker shadow.
 Look carefully. On a curved
 surface the darkest shadow will
 not be at the edge of the object (as
 there is no edge!)

Fig. 21. Grading the shadows

34

Fig. 22. (1) Gradation of tone on a curved surface. (2) Contrasted with gradation of tone on a cube

Fig. 23. Painting certain objects with loving care and leaving the rest unfinished

and please the eye, should not be left till last. Work them into the painting as you go, or else they will jump out at you and put the rest of the painting out of key. Looking at the painting again, if there is a part that is too dark, a very agreeable way of lightening it in acrylic is to put a watery glaze of colour with white. The dark will shine through the white in pleasing pearly colours.

(7) Sometimes a painting has such a fresh and brilliant beginning that it may seem a good idea to leave it. A late

first idea second idea

Fig. 24. If a painting is going wrong – *boldly* repaint

chapter dealing with traditional water colour encourages this to some extent. But, where you are working with a paint that will take a great deal of working on, there is everything to be gained by doing so. It is the way that you learn. Your first still life is comparatively simple, so there are not many problems. If you feel that for a beginning you have had enough, come back to the subject another time with a fresh eye. When you do so always be prepared to make drastic repainting. Simply and boldly alter anything that you feel needs it (Fig. 24). Timid retouching up only makes the painting look fussy. Care is not a question of adding detail. Accuracy and care are the results of clear and decisive thinking. Studying the beautiful and intense still lifes of Morandi, you will see, that he always preferred still life in modest and neutral colours, often only in shades of white. These neutral colours contain a world on their own. There is no reason, if you like them, why you should not paint endless numbers of still lifes in these colours. No doubt however, you will want to go on to something else. So the next approach will be:

STILL LIFE OF COLOUR AND RHYTHM

While this will also contain form (which we have already examined), we must now think of rhythm. Seeing form,

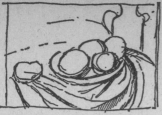

still life of rhythm – using drapery to unify the objects

Another kind of rhythm

Fig. 25. Rhythm

rhythm and colour, and learning how to paint them, will prepare you to go on to landscape and figures.

(1) Perhaps drape the background with a colour, some fruit, a jug and a white cloth. Many painters use white as key in the painting to gauge all the other tonal colours (Fig. 25).

(2) Some drawings to start. Drawings are a way of sorting out the shapes before you begin, and, working off the most difficult problems. With your view finder, the objects placed low, you get the feeling of a landscape (Fig. 26). Or maybe a closer view of the rounded and sensual coloured fruits appeals to you more; do several drawings, linear and tonal. Look at them for a moment; are the tones balancing in a pleasing way? Is something going to dominate the whole painting (Fig. 27), so you may have to move it to one side?

(3) To begin painting. With a thin brush outline the main shapes. Now with a large brush, possibly a nylon one, lay in the main colours in thin watery paint. Take care at this stage not to get ridges in the paint, as these can be annoying to work over. The painting should be clear and well defined on the board. Keep your brushes well rinsed in water at all times as you are painting. Add more paint, somewhat thicker, to the whole painting. Try to keep the colours as simple and clear as you can. There is fruit. Perhaps some apples are green. Start then with bright green. Is it too bright? Add some yellow and some retarding medium to give you time to add some white. Paint the shape on fairly liquid, and boldly. Perhaps some fruit next to it

37

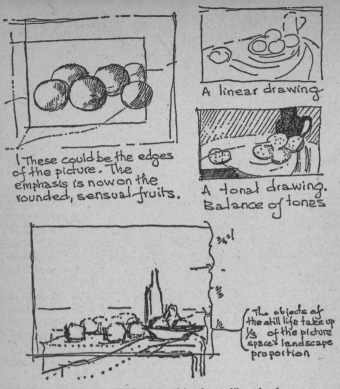

I These could be the edges of the picture. The emphasis is now on the rounded, sensual fruits.

A linear drawing

A tonal drawing. Balance of tones

3/4" = 1

2/3

1/2

The objects of the still life take up 1/3 of the picture space = landscape proportion

Fig. 26. Placing a still life composition low – like a landscape

Fig. 27. A sharp tone or anything cutting the picture space in half can dominate a still life

Fig. 28. You can glaze, with cross hatching, the colour form of an apple
(or cheeks for that matter)

is red and green. What about the red? You can paint the
main area first in green – it may need some yellow ochre with
it. Then, almost immediately you can paint over the red in
a glaze with plenty of water (Fig. 28). One thing about
acrylic, it stops you mixing indefinitely. You have to make
a decision quickly. Endless mixing only makes a painting
muddy.

(4) Some colour now in the background. Perhaps part of
it needs darkening. Either mix the colour of the background
with a darkening colour like black brown, or, see if you can-
not darken by adding some other colours like monestial
green and violet. A good way of darkening colour is not to
mix but to glaze on the darker colour. This makes the
colour more luminous. Where you may have to lighten, do
not always resort to white. This is the first thing that gives
a chalky effect to colours. The following rules may be helpful:

Turquoise lightens other blues, and violet.

Orange and yellow lighten red.

Yellow ochre, yellows, turquoise lighten greens.

Most colours lighten umbers, except monestial green and
violet.

These colours should be glazed and mixed.

(5) Stand back. Check tones, check shapes. Now it is
time to decide which way to take the painting. You can
turn it into a design based on natural objects, as in Braque's
still lifes (Fig. 29). Or you can go on and develop it as an
analysis of nature.

(6) In the first method, you can work on the painting
away from the subject. You can change the design about to
a great degree without the objects entirely losing their

39

Fig. 29. Some traditional man-made objects that keep their recognisability however much they are stylised

identity. You should try using a palette knife. It is a delightful sensation putting on slabs of paint with a knife. You can make the paint very thick and it will not shrink or peel off. It is light too, as acrylic is porous. It will dry quickly, so there is not much opportunity of pasting the paint about once it is on the board. You can, though, glaze colour on top afterwards This makes a most attractive luminous effect Stand back and check the tones and shapes. Do they need altering? If you think they do, make a brave and direct alteration. It is always better to make a clear, bold decision in a painting, even if it does not go quite as you wish.

(7) If you have taken the alternative course and wish to go ahead analysing natural appearances, we will now think about this. The first thing that may strike you about your painting is that it looks flat. How then, to create the illusion of solidity? We have studied, in the first exercise, how to make a form look solid. It can be a question of adding a brown to the colour of the main object and that is about all (I have not mentioned black; it is a very drastic, cold darkener.) The Impressionists taught us to see colours in shadows. Look up Chapter 8; it will give you the theory of complementary colours. Perhaps an orange has some blue in the shadows. But shadow is the absence of light, and without light you cannot see colour. So, also look to see if the colour does not lessen in the shadows. By now, you will be well on the way to painting fruit, glazing and painting the neutralising colours and shadows. They should be looking quite solid. It will now be time to stand back and . . .

(8) Look at the painting as a whole. Some parts of it will appear somewhat unpainted. The density of the paint should be kept similar all over the painting. Check. . . .

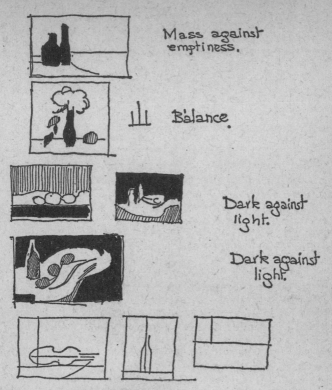

Fig. 30. The problems of still life composition apply to all paintings

(9) Tones. See that most things, in relation to absolute white, are very considerably darker. Any glitter, highlight, or white in the subject will be equal to the white on your palette, so other tones have to be graded accordingly

(10) Redraw where necessary with the paint. Alter shapes with colour. Put paint on with a palette knife if you think some part of the painting needs really decisive work. You can get luminous greys by the following method: Venetian red glazed with blue and white mixed.

Raw umber glazed with white.

Violet glazed with thin yellow ochre.

Glaze with a hatching technique or liquid washes.

Fig. 31. Balancing a still life with flowers

Another aspect of still life is that of balance. Obviously all paintings should contain elements of balance, rhythm, form, but I am emphasising them separately, as it were, for the sake of finding out about them. Balance a composition. Mass against emptiness, dark against light, horizontal against vertical (Fig. 30). Perhaps you might like to try some flowers:

(1) So to begin. You have the complicated and delightful problem of flowers – but do be wary of getting so carried away with the gay flowers that you forget about the rest! As always, paint the main areas of colour (Fig. 31). The different colours in a bunch of flowers can be distracting and become

Fig. 32. Shapes in tone of flowers

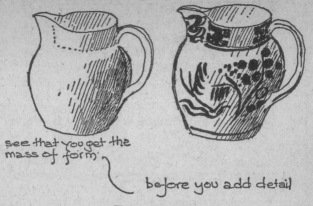

see that you get the mass of form

before you add detail

Fig. 33. Detail

very spotty, so take the greatest care to see that the tones are in keeping. See the flowers at first as shapes and forms (Fig. 32), just as you might fruit and jugs etc.

(2) Just as in the previous exercise, there comes a point in a painting when it could go in various ways. You could go on with this painting, as you did the last, either as a semi-abstraction, or as a straightforward analysis of form and shape. The artists in this class would be Chardin and Cézanne. You, however, may be the kind of painter, like the great Dutch masters, who loves the effect of light on surface, and the meticulous recording of detail. We will now have a look at this approach:

(3) Detail alone is not enough; it has to be relevant detail, and has to be part of a unified scheme. Easier written than done, but it is well worth trying. Acrylic is peculiarly suitable for this sort of painting. You can make layers of glazing very similar to the tempera paintings of the old masters. You will not, however, get a good painting if you start by trying to paint, say, the decoration on a jug, or the petals of a flower unless . . .

(4) The basic structure is sound. Check the drawing. Remember that drawing also means design (they are the same word in French and Italian). Check tonality. Build up the whole painting in thin layers of glazing.

(5) If you are really keen on flower painting and on very accurate detailed painting – and why not – turn to Chapter

43

12 which deals at some length with botanical drawing. It is possible to be inaccurate yet detailed! For example, you could have a painting where the pattern on a plate was correct, but the plate itself badly drawn. Or indeed, what would be the use of having the stalk on an apple correct and yet the apple's mass and form unsound! (See Fig. 33)

SOME FURTHER SUGGESTIONS

For the kind of decorative still life that we have discussed, why not use a coloured ground? Employ the colour of the ground as a decorative feature. This is equally suitable for a decorative, yet accurate flower piece in the style of the Dutch flower painters. Nothing is worse than a bad imitation of a Dutch flower painting. The original artists were very knowledgeable and humble toward nature.

From the solid mass of a still life object (a jug or some apples) it is not as far a cry as you might think to the next Chapter, which concerns the figure and portrait.

Usually, I end Chapters with a list of paintings to look at. I am deliberately not doing so here, as it would mean quoting subjects that have been painted in oil. The danger might be that you would attempt to use acrylic as though it were oil, so getting into difficulties because it will not behave as oil paint does. Learning to paint, while being a matter of drawing in its broadest sense, is also getting to know the way your paint behaves, and its nature.

It might be fairer to say that if any oil painting inspires you to acrylic, that is excellent, though you cannot really imitate oil in acrylic. For technique you can find far more useful ideas by studying tempera painting for thin, glazed and hatched techniques (though not of course palette knife).

It is a good idea always to have a still life arranged in the room where you work. It is always there for you to practise painting, if there is nothing else on hand to paint.

After a session of work, do clean your equipment, and make certain that the tops of the tubes are screwed on tightly.

PORTRAIT AND FIGURE IN ACRYLIC

The last chapter considered form and shape, the painting of a solid. The solids considered were comparatively simple, and if you can paint the clear forms of a jug or an apple, this is a very good starting point for the head. Not as absurd as it seems. An apple is simple, or is it? The head is complex, but not so much so that we cannot quite easily see its unity (Fig. 34). The oneness of the head is usually what gives the most difficulty.

Too many people struggle away, trying to get eyebrows and mouths 'right' when the head as a whole is not holding together. Look at a head then, mass for mass. The first thing you will notice is that the eyes, nose and mouth – that is, the face area – form a very small part of the whole. Even when you are painting a head full face on, you should keep in your eye the fact of the whole form of the head. Of course, in portrait painting this is not all. Somehow this complex yet simple form has to be part of a rectangle that is the painting. There is the body, the hands, and the background. And so we come back to a basic problem of painting composition.

Before painting how about some drawing? Why not do these drawings with a brush. Portrait and life are two branches of art where some people become very, very skilled at drawing, and yet cannot paint. It is as though drawing were in a separate realm from painting. This is because it used to be taught that if you could draw you could paint. This belief has its origins in Florentine Renaissance theory. The word for drawing was *disegni*, and had theoretical and intellectual connotations in all the writings of the Renaissance writers on art. The attitude to *disegni*, line, design and drawing was largely conditioned by the materials themselves. These were *alfresco* and tempera, which are inclined to the linear approach. If you think of the word *disegni*, it makes a bit more sense that drawing is related to *design*. Even so, it is no good for your painting to cultivate a type of drawing that has no relation to it. One way to make drawing relate to painting is to do paintings from drawings. This will teach

45

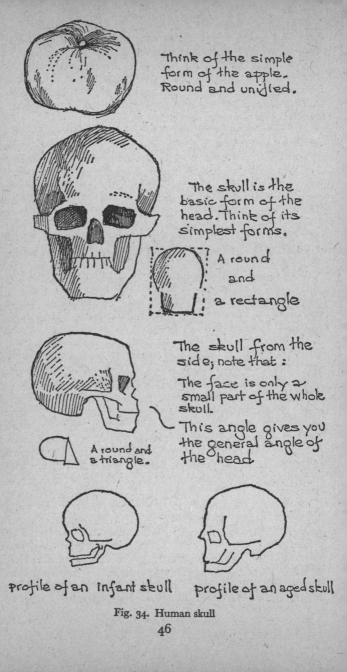

Think of the simple form of the apple. Round and unified.

The skull is the basic form of the head. Think of its simplest forms.

A round
and
a rectangle

The skull from the side; note that:

The face is only a small part of the whole skull.

This angle gives you the general angle of the head

A round and a triangle.

profile of an infant skull

profile of an aged skull

Fig. 34. Human skull

46

you to develop a way of drawing that is useful to your own way of working. The way of getting into this is to begin the preliminary drawings for a portrait in brush on paper. Use ink, or better, acrylic paint, to get the feel of the medium. Rather like the tempera and fresco referred to earlier, acrylic makes clear hard marks; you cannot get the soft lines of blurred edges as you can in oil colour.

Before we go any further, a word about the model. If you are working from the model in a group or class it is easier. A difficulty arises for your first attempts at portraits if you are persuading a friend or member of the family to sit for you. Tell them not to be too upset if the result is not a likeness, and ask them to be patient for the number of sittings you will need. Otherwise, avoid these problems altogether by getting together with a group of friends and hiring a sitter. To begin . . .

(1) Posing the model. The model should be encouraged to sit in the position most comfortable and characteristic to him or her. A model should not look posed. At least, this is the contemporary idea, though in the past a person sitting for a portrait was expected to be in an imposing and inspiring position. If you, in fact, prefer the latter course, by all means go ahead.

(2) As we saw earlier, a portrait is not only the head and body, it is the surrounds as well. Some painters do not arrange a background, but settle for the accidents of what is there already. Other artists find that a screen over which to hang drapes is an essential piece of studio equipment. I admit I thoroughly enjoy draping colours behind a sitter, seeing what goes best with their clothes and complexion. Today, clothes, especially men's, are often plain, and a patterned background gives life and variety to the painting. Many painters like white in a painting when they are painting a fair skin, as this is a very good guide to set the other tones by.

(3) To return to drawing: A good tip is not to cut the figure at the natural joints (Fig. 35). Somehow this never looks right if you do. Use your pieces of cardboard mentioned in Chapter 3 as a view finder. What do you find? Unmistakably, that the head will dominate the picture space. This is inevitable. So, next, where do you want it to be in the picture? How much of the body should there be? Where should you put the hands? Keep drawing, use bold clear lines (Fig. 36).

47

Fig. 35. Cutting a portrait at joints of the body not necessarily a good composition

Always better to make a brave mistake than something that is half right but timid. Take a look at the drawings. Are the shapes agreeable to you? Are they holding together, i.e. composed? Perhaps you have heard of this little word composition. It is rather important so I will digress a bit. Some things are composed in themselves, as it were. Other shapes automatically distract you or take your eye right out of the picture. A sudden patch of tone that is out of key with the whole is very distracting. So, returning to your portrait drawings, now think about tone. Add shades of light and dark to the drawing, again boldly. At this stage, the drawing is about the whole picture, not about details of eyes and things. Take a good look at the drawings and decide which you would like to be the basis of the final painting.

(4) It is time to put the drawing on the board. You could be using board or paper – or, if you like the idea of a drum-like surface that responds to your brush, then canvas with an acrylic ground. At some time you should have a go at all kinds of supports. The last chapter told you how to transfer a drawing on to the board or canvas (I shall write 'board' for convenience from now on). Many artists like to put the first drawing on in charcoal, though to start with, paint from the beginning is better.

(5) With the main shapes clearly on the board, now lay

48

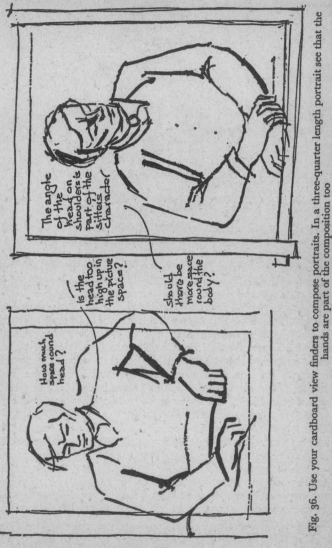

Fig. 36. Use your cardboard view finders to compose portraits. In a three-quarter length portrait see that the hands are part of the composition too

Fig. 37. Boldly lay in all the main tone – colour areas all over the
painting

in the main areas of colour (Fig. 37). Use large amounts of
very fluid paint. It will dry very quickly. Build up the paint
all over the picture in increasingly thicker layers, but thicken
the paint only very gradually. If some parts are too light,
you can darken them delightfully by a glaze of darker colour.

(6) When the main areas are well covered, you should
build up the more refined detail (Fig. 38). Stand well back
and look at the painting. Be quite certain that all is covered

Fig. 38. Detailed drawing in the head can be painted in a fine hatched
technique

50

Fig. 39. Try to see the head simply divided into the main areas of light and dark

with paint and that there are no annoying white spaces, which upset the tone values.

(7) For convenience sake, divide the areas of the head into the main areas of light and dark (Fig. 39). As acrylic is transparent, you might like to try dividing the light and dark of the head by painting the shadows in venetian red or green, like the old masters of tempera. This means, that, when you glaze on flesh colours the underpainting shows through the glaze in delightful pearly tints. Otherwise, paint the main areas of light and dark in the general flesh colours of each.

(8) How to mix flesh colours, for white skins:

White + yellow ochre and venetian red, in varying proportions for the average male skin.

White + yellow ochre + vermilion, in varying proportions for the average female skin.

White + lemon yellow + rose for a very fair skin or a child's skin.

To make soft shadows on these mixtures, glaze gently with green, raw umber, or blue, mixed with a spot of white, glazed on very thinly.

To make a full shadow:

Venetian red + raw umber + yellow ochre. If this proves

51

to be too heavy mixed thickly, use it over a lighter colour as a glaze. The hatching technique is useful in acrylic, and is good for getting very careful and detailed drawing.

The above mixture described is for a warm shadow. A cool shadow may be useful to effect contrast and modulate the form. A cool shadow is based on blues and greens: indeed the complementaries of the main flesh colours. You can add a touch of blue or green to a dark flesh colour to get a medium cool shadow.

(9) To mix colours for a dark skin:

Yellow ochre + venetian red and raw umber in varying degrees. This makes a very warm colour. You could add a touch of white, at risk of making the mixture go muddy. Better, I think to glaze over with a light mixture of white and lemon yellow, when the underpainting is dry. If the flesh colours of a dark skin are *so* dark when observed in full light, you will appreciate that the shadows will be darker still. A good mixture is raw umber with some dark green + violet.

(10) Some more flesh mixtures for white skins:

Orange + white and a touch of ultramarine.

For yellow skins:

Yellow ochre + white and a touch of vermilion.

(11) You have the main areas of light and dark of the head. Now, measure the spacing of the eyes, nose, ears and mouth. Place the main areas of tone for the eyes and nose, and the tone of the hair too.

(12) Take a look at the whole painting. There is a lot of work on the head, so the rest may be looking a bit empty. As for still life in the last chapter, it is not good to have the centre of the painting finished and the background left as an afterthought. Add *now* some paint all over the painting. You may have to modify the colour you first put on. If there is a mistake, you cannot scrape out, all you can do is use the mistake to good advantage or paint over it. Supposing you had painted something the wrong colour, try and experiment with a thin glaze of some other colour over it.

(13) Check other proportions. Are the shoulders the correct width in relation to the length of the body? Are the shoulders tilted at any angle? Check the tones. Is the colour of the flesh too light? This can make a skin very chalky and not agreeable to look at. If it is too light, mix a version of the flesh mixture you used before with less white, and glaze this on. Do not be tempted to add highlights to the head

You can get likenesses if you
measure proportions correctly —
(1) Measure length of head in relation
to width — Widest point of head is at number 6
(2) Where is the halfway line in the
head?
(3) Centre line of mouth in relation
to bottom of nose and chin. Also
check where corners of mouth
come in relation to centre of
eyes. Remember, the centre line
of the mouth gives the mouth
its shape — Also mouth to nose width.
(4) Bottom of ear and top of ear in
relation to nose and eyes.
(5) Width of forehead in relation
to distance from eyebrows to end
of nose.
(6) Width of cheek bone possibly
widest point of head. Check its
width in relation to angle of
jaw at 7

Fig. 40. Obtaining a likeness

53

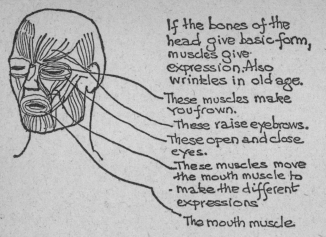

If the bones of the head give basic form, muscles give expression. Also wrinkles in old age.

These muscles make you frown.

These raise eyebrows.

These open and close eyes.

These muscles move the mouth muscle to make the different expressions

The mouth muscle.

Fig. 41. Muscles of the head

at the end, work them in as part of the modelling as you go along.

(14) Take another look. Is the problem of whether there is a likeness the next thing to deal with? So much is talked about likeness. There are many ways, too, of interpreting any one person. Everyone has so many aspects of their personality, that a painting cannot hope to catch all of them. Indeed, when we interpret a personality, it is the unconscious selection of characteristics to depict that in the end tell as much about the painter as the painted.

To return to paint and board. To obtain a likeness proportion must be accurate. Check proportion again (Fig. 40). In painting a portrait one will find that the sitter will talk to you and sometimes fall into repose. Decide which is most characteristic of them; the animated or the contemplative. A sitter will often enough take a different pose for each mood. The fleeting expression is concerned with the structure of the muscles of the head, though the shape of the skull will of course remain unchanged (Fig. 41).

(15) Hands by tradition are difficult. Where people put their hands is characteristic of them too. Always remember that the person's way of sitting is part of the likeness you are seeking. One of the reasons that royal portraits are often not

Body indicated by broken line -----

Fig. 42. Bends and joints in the body affect clothes and drapery

as satisfactory as they could be is that the long suffering artist has neither time nor opportunity seriously to paint the whole figure. The head is often perfectly good but the rest 'falls apart' as it were.

(16) Check that the body really looks solid and convincing under the cloth. Make sure that drapes and clothes are really on the body (Fig. 42).

(17) Have a look at the background colours. Are they painted enough? Is there any detail that is distracting? Sometimes the very thing that you may have been working on for ages is that part of the painting that distracts from the unity of the whole. There are two methods of dealing with this problem. Either painting out altogether, or painting

the other parts of the picture to the same degree of intensity. The latter suggestion is less depressing than painting out a part of the picture on which you have taken time and trouble!

(18) Generally in any painting, one breaks the large masses down into detail. As one increases the work on a painting one must, at all times, check the tones as one paints into the surface. This prevents the detail jumping out at one and distorting the unity of the painting.

(19) Take a look at your painting. You may find that you have enjoyed painting the portrait and you have a natural response to painting and interpreting personalities. It may be that the painting has fallen short of your expectations, though it is obvious you have come away learning something more about painting. If you feel that portraits are what you want to paint, and yet your first effort is not much good, take heart. Painting can be learned, and if you try hard enough, it will undoubtedly improve!

Having tried flesh colours, you will probably at some stage want to attempt that most basic discipline of all, the nude. At first I admit I could not dissociate the nude from the great oil painters, who had gently smudged outlines and forms, and had quite obviously worked paint into a previous coat of wet paint. Examples are Titian, Velasquez and Gauguin. This, though, takes no account of two of the greatest nudes of all time; Raphael's 'Galatea' in the Villa Farnesina, Rome, and Botticelli's 'The Birth of Venus' in Florence. These paintings, if you look at the reproductions, or ever have the good fortune to see the originals, are linear and glazed. Their treatment is admirably suited for the kind of approach demanded by acrylic. Indeed, before starting this chapter I copied both in acrylic. The delights of Botticelli's beautiful nude are the transparent glazes that give the marvellous limpid flesh colour. The same effect is also seen in his 'Mars and Venus', nearer to home in London, as well as in the Three Graces in the 'Primavera', the latter being in Florence. Perhaps in our present way of looking at life, Raphael's lovely Galatea does not seem to us as ideally beautiful as she did when she was first painted. We live in an age where the ideal beauty which the age of Raphael associated with ultimate good, is scarcely that generally accepted today. Indeed the nude as an object of pleasure seems to be out of fashion. I cannot help but think this is a

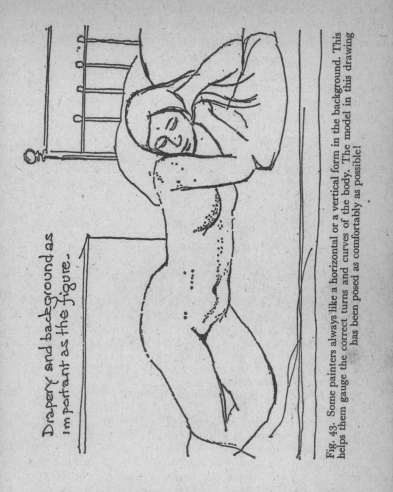

Drapery and background as important as the figure.

Fig. 43. Some painters always like a horizontal or a vertical form in the background. This helps them gauge the correct turns and curves of the body. The model in this drawing has been posed as comfortably as possible!

great pity, and I shall approach the nude as an object of pleasure in the highest meaning of the word. Actually, this could be described as the most difficult approach. By tradition the nude is difficult. We only have to look again at Botticelli's Venus to see why. Its complete unity, form, colouring, and rhythm make it an inexhaustible object of

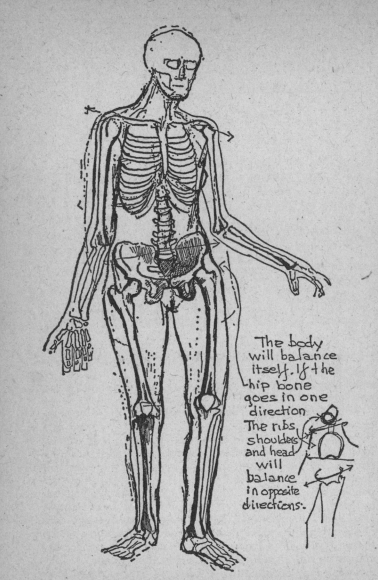

The body will balance itself. If the hip bone goes in one direction The ribs shoulders and head will balance in opposite directions.

Fig. 44. The skeleton gives basic structure and movement. This is a female skeleton hence the greater width of the hips than in a male

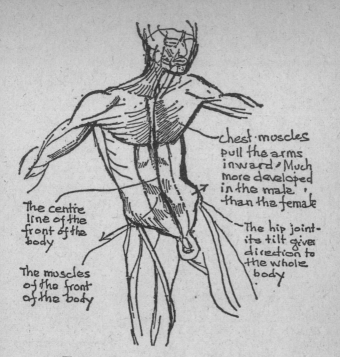

Fig. 45a. The muscles of the front of the body

study. However, enough theorising; it is time to begin your painting.

First, there are the practicalities of a model. You will either be working in classes or groups, or sharing with friends. The last is, in fact, an excellent idea, because you have some say in the pose of the model. If you decide to have the model standing, then see she has plenty of rests and does not get tired. Start by doing some drawings. Some painters always like there to be a horizontal or a vertical in the background as the object and norm of measurement (Fig. 43). I have always found this useful. It is an open question whether you need a knowledge of anatomy to study the nude. It is, of course, possible to know all about anatomy and yet one's figures never have form, rhythm or life. Anatomy should be used as a means to order our vision of the body. Think of the basic forms in the skeleton (Fig. 44).

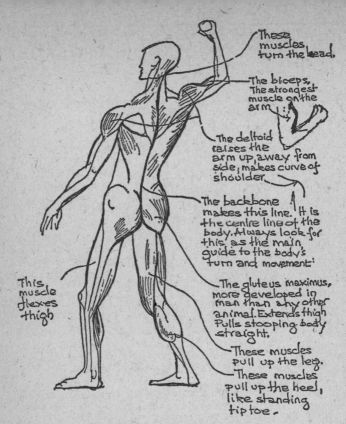

The main labels in the figure read:

These muscles turn the head.

The biceps, The strongest muscle on the arm.

The deltoid raises the arm up, away from side; makes curve of shoulder.

The backbone makes this line. It is the centre line of the body. Always look for this as the main guide to the body's turn and movement.

This muscle flexes thigh

The gluteus maximus, more developed in man than any other animal. Extends thigh. Pulls stooping body straight.

These muscles pull up the leg.

These muscles pull up the heel, like standing tip toe.

Fig. 45b. The muscles from the back

The main solid forms and movements are governed by the skeleton, the subtleties of movement by the muscles (Fig. 45). The centre line of the body is a very useful guide to the whole position; explore all these in some preliminary drawings before you begin.

Now to start painting. With variations in quantities of colour, the mixture for flesh colour given in the first part of this chapter are suitable for the figure too.

(1) Cover the board in the main tone colours. In a nude, underpaint in the whole form in grades of a single colour. Like the old masters, you could use pale green. Flesh colour

60

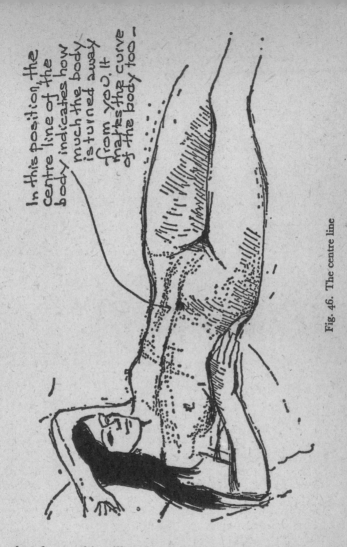

In this position, the centre line of the body indicates how much the body is turned away from you. Notice the curve of the body too — it is foreshortened too.

Fig. 46. The centre line

glazed over this will make the green show through a tone darker. If you use a stronger colour like raw umber, the flesh tints over this will make the raw umber shine through as a sort of optical cool tint. You could underpaint in both

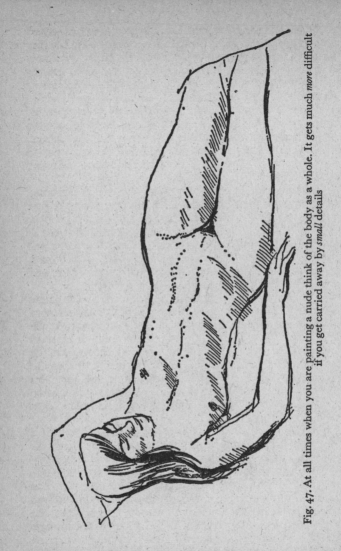

Fig. 47. At all times when you are painting a nude think of the body as a whole. It gets much *more* difficult if you get carried away by *small* details

colours. Underpainting in venetian red will show through to a strong cold grey, almost blue. The first cause of unity is the oneness of the drawing (Fig. 47).

(2) When painting a nude, mix a large amount of watery liquid colour to the most general colour of the body. Looking at the body, it is very easy to see it as a diversity of colours. Take a general colour, not too light nor too dark. Bravely cover the whole area of the body. Do not at this stage pause to worry if it is right.

(3) Proceed to more painting on the rest of the picture. As much as concern for form in the nude itself, you should be concerned with the form in every part of the picture, drapery backgrounds etc. Do not worry if things appear to be going wrong. There is only one thing to do about this, and it is to go ahead!

(4) Redraw the figure as required with the background and the drapery. Coming back to the figure, you may find that the shadows overpainted with the flesh tints are now too cold and pale. Indeed, whenever you paint with a thin paint containing white over a warm colour, the result will be a cool, lighter colour. So mix a warm shadow. You may, while you are working, have to add retarding medium, and draw with the paint into the body to give it form.

(5) To return to a point made earlier about parts of the body having different colours. The trunk of the body is more often than not lighter than hands, feet and arms. At the moment the whole of the painting of the body is more or less the same colour. For different areas of colour mix the colour you need, and gently glaze it on, merging into the main colours. On the subject of hands and feet, one sees nudes by very good painters that tail off at the extremities. Accurate painting of relevant information are essential to the whole painting.

(6) Think again about the surrounds of the body. Is a plain area of background looking too plain and unadorned? If it is because the colour in itself is plain, then you can vary the colours within the colour. This means if it is blue, some parts could be lightened, other parts glazed with blue and green, or blue and purple. Other parts could be neutralised by adding blue to its opposite (Chapter 8 gives you the theory of complementary colours) which in this case is orange.

(7) On the subject of neutrals, you may want, on some part of the body, to effect a turn of form that curves only very gently. There is a slight turn in the form, not enough for an entire shadow, but some. With any mix of flesh colour that you are using, add a drop of retarding medium, then

a touch of the opposite colour, and you will have the slightest variation in the colour. Use thinly.

(8) Now stand back. There are times when, in a painting, one should go bravely on, and there are times when one should take stock of how things are going. Ask yourselves the following questions:

Whether the proportions are working?
Whether the tones are working?
Whether the colours are in tone?
Whether the paint is equal in density?

Perhaps you feel this is all rather obvious. This is what painting is about. There are really no special secrets. It is a question of revealing the obvious. Easier written than painted. Never look for some hidden truth, look for the obvious.

To return to practicalities, there are two ways of looking with clear detachment at your work. (Rinse your brush whenever you can – another practicality!)

(8) First, have it in your room, especially the bedroom, so that it forces its presence upon you. You will suddenly feel that you must repaint something. Turning a painting upside down helps! Or looking at it in a mirror.

(9) Secondly, be very strong minded and turn its face to the wall and later come to it afresh.

(10) If there are any startling defects, one cannot emphasise enough how important it is in any painting to be very drastic about repainting. It is in fact very agreeable to do this in acrylic. It paints on so cleanly and clearly without disturbing the underpainting. You can do this with slabs of palette knife if you feel like it. This is drastic, but if the effect is harsh, then you can always put softer glazes on afterwards.

(11) Dark skins. Whenever I have painted dark skins I have noticed that the tones are more unified. You do not usually see nearly such sharp contrast between light and shadow. The colours for painting dark skins are given earlier in this chapter.

(12) Most painters like to complete a nude or a portrait away from the figure. This is because they can then concentrate entirely upon the painting. After a time, many painters find the complexity of natural phenomena confusing. Some, like Sickert, drew from nature and sometimes only painted from the drawings, thus not painting directly from external nature at all. It is a very good idea, where you are

entirely dependent on some outside circumstance like a model, to learn to paint the subject entirely from drawings.

When you look at your painting you may feel that it will be improved by cutting some off, especially if it is on hardboard or paper. Well, please yourself, but it is a very dangerous habit to get into!

There are two very distinctive and original painters of portrait and figure in acrylic: Patrick Procktor and David Hockney. They are both British, and their work can readily be seen in Europe and U.S.A. The history of acrylic does not go back far enough to provide many artists from the past. However, if you feel like copying, you could do no better than copy the painters who worked in alfresco and tempera. These are the great Italian masters, Botticelli, Raphael, Michelangelo, Piero della Francesca, etc.

TOWARDS LANDSCAPE

It was difficult to give this chapter a title. It is about external appearances, but scarcely in the mood of the contemplation of landscape that was possible in the past. Over seventy years ago, one could, in most places contemplate 'unspoiled' landscape, untouched by the hand of man. Now, at any rate in Europe, most scenery we look at bears unmistakably the imprint of man. There are roads, chimneys, buildings, cars. Indeed man dominates most landscape now quite definitely. Should one attempt in one's painting to ignore or escape the works of man, pretending to one's board that it is not there? This, I cannot answer, but the bias of this chapter will be towards a picture of contemporary life in relation to surroundings in landscape, sea and buildings. Even if you like, in the romantic tradition, to contemplate landscape as a poet might; identifying nature's moods with your own, there will be parts of the chapter that are still relevant, and so will parts of Chapter 9 on water colour and landscape.

Acrylic is so very convenient to take around with you, that you should always take some away with you on holiday. There is no problem of board or canvas, as you can paint on to paper. Often, on holiday, one has wanted to sit down and paint a scene quite spontaneously. Equally often, though, one has to make do, as it were, with a sketch book, making drawings for later paintings. We will, in this chapter try to concentrate on painting pictures directly on the spot, without any great number of preliminary drawings. Acrylic dries so quickly and it is so convenient that you might as well paint directly as draw. In any case, you *always* have to draw with paint.

So, you are travelling with your paints ready. Perhaps you are going by car when you can stop as the fancy takes you. Or you may just be walking along. The idea to bear in mind is the fact that you want to paint. This will condition your seeing. Something will strike your eye that you feel wants, as it were, to be a painting. So do not waste time, just begin; do a couple of preliminary sketches, but start

66

painting at once. Before you know where you are you will have a picture.

Your equipment. All your paints, brushes, a plastic palette, a very small sketch book. Either a large sketch book with heavy cartridge paper, or several pieces of cartridge paper clipped to a board. If you are far away from an art shop, brown paper will do as well. Do not forget a container for your water, and also a very large plastic bottle of clean water. It is incredibly frustrating to be stuck somewhere without clean water, and have to struggle along with the dirty, clogged variety from a pool or brook!

Some kinds of landscape. Not so long ago, some artist friends and I were on an expedition to the sea. We were so intrigued by the drama of the industrial landscape, with chimney stacks, and stark fundamental forms, that we painted these instead. This is indeed the hand of man in landscape. It has a stark and noble beauty, with dramatic horizontals and verticals.

Any landscape and all landscape has one thing in common: the effects of light. Whenever you look at landscape, decide where the light is coming from. This is the first decision you must make.

(2) Then consider how to divide up the picture. How much is to be sky, or land (Fig. 48)?

(3) Is there a centre of focus; what, indeed, is the centre of interest that made you choose the subject in the first place. It might be an imposing view of factories, or a cathedral city (Fig. 49). Should you let anything be the absolute centre of the picture or will it spoil the composition? The above problems you can sort out in preliminary drawings, but it is important to start painting as soon as you can.

Tone colour and light are inseparable in landscape of any kind. So, as you paint in the broad area of colour, you should be thinking of the distribution of tones as well.

(4) As you cover the area of your board with paint, it is as well to sort out a tone of colour for the nearest part to you, the far distance, middle distance and sky. Objects close to you will be brighter, and there will be greatest contrast in tonality (Fig. 50). Things, as they are further away from the eye, lose colour and tone.

(5) In an industrial landscape, horizontals and verticals are useful norms of measurement.

(6) Decide which is to be the lightest thing in the view.

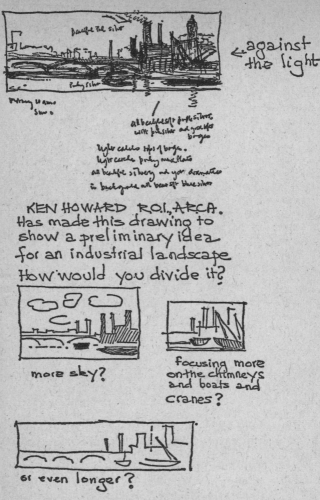

KEN HOWARD R.O.I., A.R.C.A. Has made this drawing to show a preliminary idea for an industrial landscape How would you divide it?

more sky?

focusing more on the chimneys and boats and cranes?

or even longer?

Fig. 48. Landscape composition

It may be the glisten of light on water, or the white of clouds, or the white of a building reflecting sunlight. This should equal the white on the palette. Other colours should be toned down accordingly. The more you tone down other colours in

68

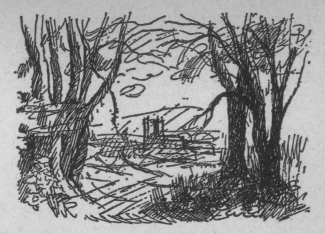

Fig. 49. A landscape with a centre of focus, made by the subjects as well
as by the framework of trees

contrast to the lightest, the more the very light colours will
show up. Some lights, especially in northern countries, show
more colours than others. A grey day will narrow the colour

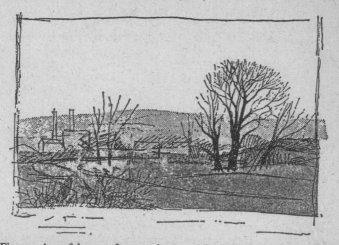

Fig. 50. A useful way of measuring tonal intensity is to think of the
nearest, middle distance tone, the furthest and the sky. In this sketch the
sky is the lightest

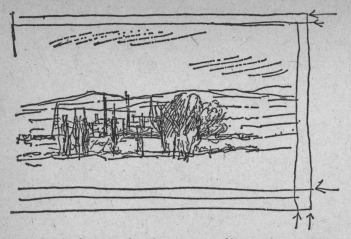

Fig. 51. A landscape need not have a centre of interest, it can be about the expanse of sky, and distance. At which arrow marks would *you* divide up the painting?

and tonal range of any scene, town or landscape. A very sunny noon day that has short shadows will take the colour out of everything too. This is particularly so in the Mediterranean.

To return to an earlier point concerning centre of focus: Apart from all other considerations, a landscape need have no actual centre of focus (Fig. 51); it can easily, and often is, only about light, distance or sky. If you are painting skies in acrylic, you can get delightful effects of the crispy clouds by applying the lights with a palette knife. This does not mean sloshing white all over the place! Look very carefully to see the true colours of the clouds. Often they are a slightly creamy colour, in contrast to the blue sky. Perhaps then it is a painting of the sky and fields, with all the greens and other colours.

Here are some suggestions for mixing and painting colours in landscape. You can get the brilliant transparency of greens by first painting in lemon yellow and glazing with a thin layer of monestial green. A duller green can be effected by glazing yellow ochre with monestial green. This may be too bright. You will get a slightly duller effect if you mix the colours rather than glaze them. Rowney manufacture a

Fig. 52. A river as a lead-in to a picture. A road can do the same

bright green. It lives up to its name! It is very useful for paintings of spring when greens are bright. It can be toned down very agreeably with a touch of blue and/or raw umber. Try, where possible, not to mix white with everything indiscriminately. This leads to a dense chalky effect that is the very opposite to brightness. Take great care when you are painting earth. Some painters use a 'boot polish' sort of brown quite indiscriminately. When you look you will see that earth can be the softest sort of umbers, even grey. You probably do not have to be told that a blue sky can be mixed with ultramarine, cobalt, and sometimes turquoise (I am addicted to turquoise in acrylic – it is not made in any other medium, so this is the only chance of using it!) To get a really brilliant sky, as in the south, first put on a ground of very thick white, wait till it has dried, and then glaze with a thin wash of blue.

A lead-in to the picture is a very usual feature of landscape (Fig. 52). This can be a road or a river. Perhaps it has turns if it is a road. Roads in an industrial landscape often have vehicles that can provide a delightful patch of colour every so often. Sometimes industrial subjects incline to greys and

although greys contain an infinity of variety, it can enhance them to have a patch of colour. A road or lane can also lead you right into the picture, but take care that this does not take your eye to one place and you will not look at anything else. The picture will show you how to combat this. All these comments are true of rivers and streams, except that water can be the lightest thing in the picture – lighter sometimes than the sky, or just as light. In some landscapes the river may be a browny sort of colour, with sudden bright reflections. If water is moving rapidly, the light on the surface will be much more broken up.

If you are painting on a sunny day, whatever the season, the light will change after about three hours. It is pointless struggling on when the light is quite different. If you are painting in a changeable climate you take the risk that you will not find the same effects the same time on another day. So you will have to finish from memory – which most people prefer to do anyway. If you know that time is limited, do not be tempted away from the main subject to add details; try to keep your treatment broad and direct.

To return, though, to the subject of river and streams. By rivers you can often see delightful subjects that one wishes one could paint. It may not be the stretch of a river. It may be a closer view with folk picnicking or fishing. Perhaps the figure by tradition is difficult, but take it simply, and it will be easier than you think.

In a thin wash of any colour, paint in the main areas broadly. If you are painting out of doors, a good idea is to lay in the middle shadow tonal colour to give the picture unity (Fig. 53). Take a careful look – are the shadows blue, or greenish, or brown? There, you have the main areas of shadow. What are the colours in the light, bright greens, blues? Paint them in boldly, shape for shape. Paint quite thickly if you like, as long as there are not too many ridges in the paint. Before you know where you are you have the beginning of a picture. Rinse brushes all the time as you go along.

Now to go on with the picture. As it may be looking somewhat empty, clarify the shapes with colour and line. Draw on to the surface of the picture with transparent colour. Remember that transparent colour with white will make a grey. A transparent unmixed colour over a lighter colour will give a clear luminous effect. If there are people in the

Fig. 53. Middle-toned shadow painted in at the beginning can give unity to a group

scene you are painting, more than likely they will not stay still very long. In this case go on with the rest of the painting, and later ask friends or a model to take up the pose in the same position to complete the figure.

From rivers we can proceed to the sea. Having used acrylic paint, it is likely you will be wanting to use thick slabs of paint with a palete knife to make the effect of water and wave, foam, and the colours of sea. This is a case when the paint should tell you what to do. Painting like this, you can get all kinds of unexpected ideas from looking at the results of your painting. Acrylic is very suitable for recording the spontaneous. It is tempting, when painting the sea, to cover the painting with white flicks of the patette knife to make the feeling of foam. Do not overdo this or it will lose its impact. Over a heavily painted surface you can glaze with other colours. While you are painting the sea, colours and lights change very rapidly. Obviously, you cannot always be changing your painting, attempting to catch up with nature. In this case, decide early on which will change most, and paint that first. Probably this will be the sky and clouds. Then paint the parts of the picture that remain constant.

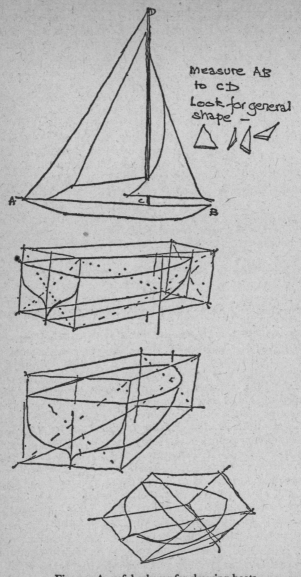

Measure AB
to CD
Look for general
shape –

Fig. 54. A useful scheme for drawing boats

74

The sea or lakes can be painted for their moods, which often enough reflect our own frame of mind. Sunlight, storms, peace, what you will. As so many of us like the sea to contemplate in a solitary way, it is worth elaborating on this.

TO COMPOSE THE PICTURE

(1) How much sea, sky? Where are the darkest parts of the painting? In a sunset picture you will have to darken some parts to show up the intensity of the lights.

(2) Never be afraid of painting exactly what your eyes tell you. A message from your eyes can come back to the brain. For some reason one thinks 'It cannot be like that really!' Ignore this, and paint what you see.

(3) Colours for the sea should need no introducing, but in case they do, here are some suggestions. The blues are obvious enough, but in a brilliantly lit sea you should look out for the reflections. What colours are they? Darker blue? Or do you see the complementary oranges and reds? If you paint any area all over with a colour, it can lose its intensity, and require some contrast with its complementary colour. Often, seas are not blue, and then you have to look out for the greys and greens of a dull sea. A very good mixture for grey-green is turquoise with raw umber. Or turquoise and yellow ochre.

(4) Then there is the sea when it directly concerns the life of people. The drama of harbours and docks, and gay little boats (Fig. 54) in seaside resorts. A dock with big ships and cranes looks difficult at first, but anyone who paints has surely at some time wanted to attempt them. If a subject looks complicated, then you set about simplifying it in some preliminary drawings. Look for the patterns of horizontals and verticals; shapes, tones of colours; proportion of ships to cranes to buildings – and you are well on your way to painting (Fig. 55). Start painting as soon as you can. Paint clearly and directly the shapes of the colours.

(5) Take a look. There can come a time in a landscape when, as in a still life, the painting could go on towards a study of the external appearances. Light, colour, atmosphere. Or you could develop it as a semi-abstract. As long as the end result is lively, holds together and pleases you and other people, both are right! The instinct to abstraction is natural to some artists. Whatever course you take, you will be dependent on the balance of tones and shapes.

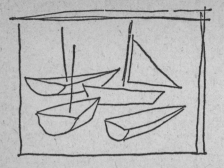

ships and boats
can be used
as patterns and
shapes and
still keep their
Identity.

This is so of buildings.

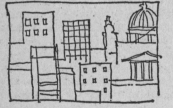

Fig. 55. Become aware of patterns and shapes

Fig. 56. The landscape in front of us and around us

(6) Buildings, too, are suitable for abstraction. Every building has walls and a roof, and all is a development from that. The finest architectural vista to the simplest cottage have this in common, so think what buildings you like best. Do you ever visit a famous piece of architecture and believe that the small dwelling houses tell you more? The suburban houses and bright gardens are more in our experience than the finest palace (Fig. 56). Perhaps on holiday, however, we see a beautiful old cathedral and want to paint that. So to begin:

(a) *Perspective.* If you want to make a realistic study, you cannot do without this. Chapter 11 gives you some rules.

(b) *Proportion.* Easy enough to measure proportion. A fine building depends on the elegance of is proportion. Look for height in relation to breadth (Fig. 57). Window space in relation to wall space. The proportion of storeys to each other. Fig. 58 shows how you can be sure of obtaining a straight line on a page. It is not difficult, is it?

(c) Tones on buildings give solidity and pattern. Look for the colours of the buildings and see if this is reflected in the shadows, or is the opposite colour? This is an effect you notice very startlingly in the south of Europe – in the sun,

77

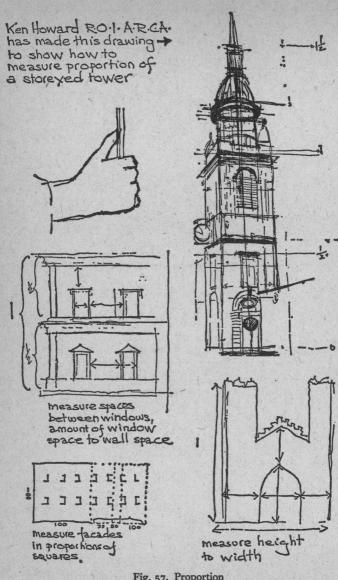

Ken Howard R·O·I·A·R·C·A·
has made this drawing →
to show how to
measure proportion of
a storeyed tower

measure spaces
between windows,
amount of window
space to wall space

measure facades
in proportions of
squares.

measure height
to width

Fig. 57. Proportion

① Hold your pen or pencil usual way on paper.

② Stretch little finger to hold edge of board or block.

③ Now, if you move your hand up and down you draw straight lines automatically!

Fig. 58. How to get a straight line free hand

the shadows of the pink and yellow ochre buildings look quite blue. The sky will look darker as well.

(d) There are many delightful colours you can mix with acrylic paint. They are suggested here, and you can get some nice crumbly effects to look very like the texture of buildings by painting on very thickly with a palette knife.

White + raw umber and all the other earth colours make the basic colours of buildings. While this is probably obvious enough, here are some other mixtures a bit more unusual:

White + orange and a touch of purple.

White + monestial green and crimson.

White + venetian red.

If ever you find a 'flesh colour' in acrylic, this can in fact, be very useful for buildings. It was *not* recommended for painting flesh in the last chapter, as it can be rather insensitive unless used with great care.

(e) When painting buildings in acrylic, I would recommend that you do not spend all your time drawing the architectural details on your board or paper filling in the colours and tones afterwards. It is better to paint the main

areas of the buildings in their general colour, adding the breakdown of architectural characteristics afterwards in paint. Remember that painting is drawing with colour!

Sometimes, when one takes out paints on an outing or holiday, a spectator is sure to make some reference to the camera. Either that it is easier, or quicker or better. It is silly to think there is any question of either/or. We paint because something in us makes us want to pick up a brush and physically respond to the surface of a support and the quality of the paint. Nowadays, people are mostly so conditioned to looking at photographs that they have come to think that they must be more truthful. They present different truths, but in no ways do the two arts contradict. Many painters use photographs as a help or inspiration. Very often, a chance snap has inspired somebody to create from it a painting much more lasting and enduring.

MORE ABOUT FIGURES

Perhaps a better chapter title would have been 'more about people'. This chapter will contain references to our surroundings (houses and landscapes), but there will be greater emphasis on the people that inhabit them. Subject matter is obviously difficult in some cases to classify, and any classification is only for your convenience. There are so many scenes we see around us, that we want to paint, and this chapter will be more or less about that. If you look at the paintings of Chardin, or Dutch interiors by Vermeer, how intensely they have raised and ennobled the most ordinary actions. Nothing could be more 'everyday' than a mother holding a child (Fig. 59), but consider the marvellous treatment of this in the great tradition of Italian painting.

INTERIORS

Study the world that is immediately around you. Look at Bonnard's beautiful oil paintings and see how he captured a moment of abundant and delicious food on a table, a meal

Fig. 59. The mother and child, an everyday sight; yet the greatest artists have painted it

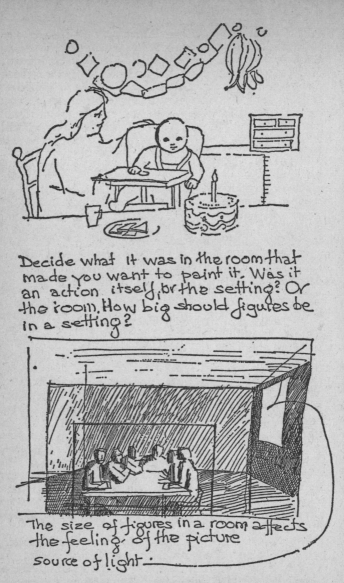

Decide what it was in the room that made you want to paint it. Was it an action itself, or the setting? Or the room. How big should figures be in a setting?

The size of figures in a room affects the feeling of the picture
source of light.

Fig. 60. Deciding on the centre of the picture

in the sun, or in the kitchen. All this is easy enough to see. Now, about painting. You see figures in rooms every day. Look for what you believe to be most relevant. Is it the size of the figures in the room. Or a section? A table perhaps? Once you look for the relative sizes of people to furniture, it is quite easy. You only have to suggest furniture and you have made an interior. When you see something that is agreeable to you, and you want to paint it, ask yourself what it was that caught your eye, that made you want to paint (Fig. 60). Make this the centre of the picture.

(1) The source of light in interiors is usually no difficulty. It comes from a window, or a lamp.

(2) Decide on how big the painting will be. Naturally, if you are painting on a small scale, then the painting of difficult detail will not be nearly so exacting. You could do lots of small intimate sketches and then with the aid of drawings, make a larger composition from them.

OTHER SUBJECTS FOR PAINTINGS

Following on from what I said at the end of the last chapter, there are many photographs today, that make us want to do paintings from them. A photograph, or several photographs, can be very useful for objects one may see only rarely and seldom have the opportunity of drawing. Looking at any newspaper, one sometimes sees very good photographs of sport (Fig. 61), racing, animals etc. Cut out and keep them, using several to make up a composition that is your own. When possible, if you are painting from photographs, you should back up these with drawings and painted studies of the subject from life (Fig. 62). For instance, if you are painting horses racing, try and make studies at the races, or of horses or both (Fig. 63). This will give the painting greater authenticity, and make it a bit more your own. This is controversial advice, as many experts on painting might say that you should *never* use photographs, as though there was deadly rivalry between the two forms. To me, however there seems to be little harm in using *anything* that inspires your work!

At first, your own drawing may look rather disappointing, beside a highly accomplished photograph. Accept the differences as being due to the way the medium works. Generally I think it is fair to say that to attempt to copy the glossiness and shine of a photograph's surface into paint

83

Fig. 61. You can find excellent photographs of sport. Copy them, varying the composition till it makes a good picture. *Try* where possible to make your own sketches from life as well. Collect pictures and sketches and drawings.

does not make for a good picture. One of the joys of paint is the character of the medium. In the final analysis, however, this book is about *your* painting, and if you want to imitate a photograph's glossy surface, or do anything else, then you must! Where a photograph is exceptionally useful is in catching the fleeting moment, frozen, as it were, in the middle of action. This is particularly inspiring for painters who like to catch the speed of animals, figures or cars, etc. In painting movement you can suggest the idea of speed by the way you use brush strokes quickly too.

Fig. 62. Look at an animal – ask yourself does it hunt? Graze? Stalk? etc. etc. Then try to see how this is reflected in its movements

At best, one would hope that a photograph will inspire you to make the paintings entirely from your own studies and drawings. If one were painting a complicated composition of a game or animals, you could scarcely be expected to paint it all from life. Make several drawings under the following types:

Fig. 63. Some sketches of horses. Think of the horse's movements and rhythm

(1) Basic compositions. Make several of these and choose the one you will eventually work from.

(2) Details of particular actions; i.e. running figures, cars moving etc.

(3) Where the light is coming from. Like in a theatre, or out of doors.

(4) Several drawings of the centre of action.

Then make some quick paintings, small ones, only about 9 × 12 inches. Acrylic is of course highly suitable for quick sketches. Repeat the sketches for composition in paint. Also repeat the sketches for tone in colours. The colour sketch may show up all kinds of things you may not have seen in a black and white sketch. For instance, when considering composition in colour – does one lot of colour upset the balance? Does a patch of colour distort everything else?

(5) You will also need drawings of the details of feet, hands, etc. In the case of animals that you cannot usually see, a very good place to draw the details of animals' heads, feet, etc., is a museum of natural history.

This chapter can usefully be completed with illustrations on how to draw various subjects. It should be said that at all times, your sketches can be toward an abstraction of a subject as much as a purely figurative painting. As an example, I can highly recommend you to look at de Stäel (d. 1955), who painted many semi-abstractions of footballers with a palette knife. They are brilliant patterns of colour and form. Admittedly they are oil paintings, but the fact that they were painted with heavy slabs of paint means that they can be useful to anyone painting in acrylic. While you are about it, look at other paintings by de Stäel.

A figurative painter who works in acrylic is Leonard Rosoman, R.A., whose paintings can be seen in the Royal Academy Summer Exhibitions. Acrylic is increasing in general use. Look, every time you go to an exhibition what paintings are in acrylic, and see what new ideas you can learn from them.

Remember, clean your painting equipment in water as you go; *afterwards may be too late*!

I appear rather to have stressed the coloured photograph. It should also be said that black and white photographs are of great value to see the tonal values of distance and colour.

TRADITIONAL WATER COLOUR

By 'traditional water colour' we mean using water colour in much the same way as it was used by the British eighteenth-century painters. There are so many painters who still use water colour in this way, that it cannot be said that they use water colour in this way just for the sake of tradition. The reason is that painters still find it agreeable and satisfying to respond to fine papers, and excellent brushes. Water colour of this kind depends a great deal upon the quality of the materials. On no account can the painter be mean with materials and hope to get by with cheap or inferior products. The eighteenth-century painters and others until quite recent times had one great advantage over us. This was the ready availability of hand-made papers. Until about 1820 all papers were hand-made. The importance of fine paper in water colour cannot be neglected so here are some comments. Today, there are a vast number of papers made for every possible use. Paper technology is one of the major advances in the modern world, and many, many substances are used in paper making. The most used for ordinary papers is wood pulp. In time, though, the resulting paper yellows and crumbles. Finest papers are made of rag, which lasts indefinitely.

Hand-Made Paper is made in the way it has been made in Europe for centuries. Linen and cotton rag are pulped in water in vats. Then a mould is dipped into the vat. The mould is covered with wires to a 'laid' or 'wove'. This strains out some of the water from the pulp, and gives the paper its surface (Fig. 64). The surface of water colour paper is of great importance to a water colour painter. Then after the paper is in the mould it is taken out and pressed between 'felts', to extract all the water. Then the paper is dried in lofts. You will always find that hand-made paper is marked 'Hot Pressed' (H.P. for short) or 'Not'. Hot Pressed means that there is a smooth shiny surface, and 'Not' is a rough surface.

Mould-made Paper means that the moulds are dipped into

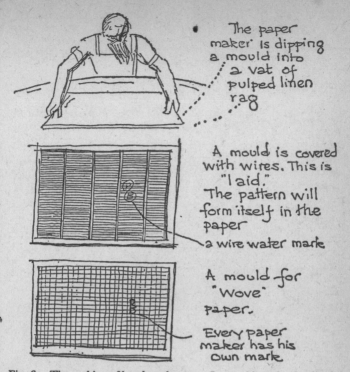

The paper maker is dipping a mould into a vat of pulped linen rag

A mould is covered with wires. This is "laid." The pattern will form itself in the paper

a wire water mark

A mould for "wove" paper.

Every paper maker has his own mark

Fig. 64. The making of hand-made paper. In mould-made, the dipping is by machine

The sizes of papers (subject to some variation)
Demy 20 × 15½ inches (51 × 39cm)
Medium 22 × 17½ inches (56 × 44cm)
Royal 24 × 19 inches (61 × 48cm)
Imperial 30½ × 22½ inches (77 × 57cm)
Double Elephant 40 × 26¼ inches (101 × 68cm)
Antiquarian 53 × 31 inches (134 × 78cm)

the vats of pulp by machine. By law in England you cannot sell mould-made paper as hand-made. There are some excellent and beautiful mould-made papers of the highest quality.

Tinted Papers. In the past, many hand-made and mould-made papers were tinted to a blue or brownish grey, though these are not made so often now. Very beautiful coloured papers are made in the Canson, Swedish Tumba and Ingres.

French Ingres papers are of beautiful and unusual colours, rather like tweeds.

Machine-made Papers are the kind of paper in general use. Every part of the processing is done on a commercial scale entirely by machine.

Here are some descriptions of hand-made papers, which, unless stated, are made by J. Barcham Green of Hayle Mills, Maidstone, Kent. They can be obtained at any art shop, or directly from the mills.

Pasteless Boards are made from 100 per cent cotton rag and gelatine sized. They are heavy and thick, and do not need stretching. They also have a delightful crumbly wove surface, with the exception of 200 lb. H.P., which is of course smooth, and is a beautiful surface for architectural or plant studies. Pasteless boards are very strong. You can paint on them, and then soak the board in a bath of water to wash the colour out, or to make the colour run for effect, and no harm will come to the board.

Barcham Greens R.W.S. hand-made paper have rough wove surfaces, in various thicknesses. The 90 lb. hot pressed is particularly smooth surfaced and good for detailed work. Wove papers have the advantage that you can drag a brush over the surface, and it does not colour all of the paper. Instead you have little specks of white showing through, which gives the colour a rather attractive sparkle. You may, however, find you like a laid paper better. Barcham Green make a hand-made laid 'Antique'. The French makers Canson make hand-made Ingres laid paper which comes not only in white but many beautiful colours. All laid papers should be stretched. The tinted hand-made papers are generally very rough surfaced. One is expressively called porridge paper which gives you an idea of its texture. There is also a neutral coloured De Wint and a Turner paper. These papers must generally be stretched unless you are using small areas only.

Mould-made papers are very good for ordinary purposes, and Barcham Greens' 'Bockingford' has the singular advantage of a surface that is somewhere between hot pressed and very rough. Swedish Ingres style 'Tumba' papers are mould-made, and come in a variety of delightful soft colours.

The whole basis of traditional water colour is that the paper is as important as the colour. The paper gives quality to the colour and on no account should you think of under-

estimating its value to a successful water colour. At first, you should experiment on as many kinds of paper as possible, as most painters find that they have their favourite paper. Throughout the book I have indicated when you need not use the most expensive paper and when you can use ordinary machine-made drawing papers. One word of warning – rubbing out on the surface of almost any water colour is harmful. Therefore the list of equipment makes no mention of rubbers. However high the quality of the rubber, the friction is not good. It is a much better discipline to learn to work without any rubber. Barcham Green, Saunders, Hodgkinson, all make other mould-made papers of a variety of thicknesses and surface. They have always seemed to me to be quite as good as the hand-made, and the definitions do not suggest a difference in quality, only in methods of making.

Most good art shops stock Japanese papers. They come in a large variety of fascinating colours and textures. But they are unsized and therefore it is rather like painting on blotting paper. I find it impossible to use them, but there is no reason why you should not experiment with them if you want to.

Once water is put on paper, unless it is very small in area, or very thick, it is inclined to cockle. If you are using a very small made-up block of water colour paper the paper will not cockle, but, otherwise you should take the precaution of stretching your paper. Fig. 65 shows how this is done.

You can either leave the paper to dry after stretching, or work on it while it is still wet. More about this later when we discuss the techniques of painting. It is when you stretch paper that you become very forcibly aware of its quality. With cheap paper, after being wetted and stretched, the surface will be ruined, and rather disagreeable to work. Fine quality paper will take any amount of soaking and stretching. A fine quality paper surface might stand quite a lot of rubbing out, though in this case, prevention is better than cure! It is better to develop a sure hand, than rely on a rubber.

It is worth experimenting at first with every kind of paper to see which suits you the best. This is very personal, and depends on your response to the surface. There are times when you are more likely to need a smoother, shinier surface. This could be when you are making a detailed study in water colour of plants, or architecture. So, as a beginner to water

To stretch paper you will need—

plenty of clean water

clean sponge or rag

gum strip (the kind you have to wet, not self adhesive

drawing board, paper.

put the paper on the board wet thoroughly with sponge in water, from the middle of the paper out to the sides.

Turn paper over. Repeat. Now stick paper down with gum strip, round all sides. The paper can be painted on while it is wet. Or you can leave it to dry. If you put washes on paper that has not been stretched, it will "cockle," i.e. form a bumpy and uneven surface.

Fig. 65. How to stretch paper

colour, it might be as well to start by buying a selection of all kinds of paper, and see how you get on. Once you have got your water colour paper, keep it carefully; do not be tempted to handle it over much, as it will quickly pick up a depressingly grubby surface.

Fine papers indeed, like all traditional water colour materials, are not cheap, though at first, as the next chapter will show, you can practise on the less expensive papers.

All papers are made in sizes. The most usual names and sizes for drawing paper are given in Fig. 64.

BRUSHES

The sable brush is used for fine water colour (Fig. 66).

wash or sky brushes They are made of squirrel hair

The shapes of sable brushes

Fig. 66. Brushes for water colour

Sable is the best of all animal hairs for brushes. It is strong, flexible and has a delightful response to water and the support. While you are probably well aware of the fact that sable brushes are very expensive, with care, they last a very long time. For broad large paintings you can use squirrel and kolinsky brushes. Some cosmetic manufacturers make sable brushes. For some reasons they are less expensive than their equivalent in artists' brushes, but are perfectly good to use for water colour.

CARE OF BRUSHES
Is a basic and vital discipline of painting and it should never be overlooked or neglected. Brushes for all media should be kept quite separately, and you should have a different set for each medium. Be sure you rinse brushes thoroughly.

PALETTES
Paint boxes have palettes attached. You will probably find you will need more space for mixing washes. Anything except a wooden palette is suitable for water colour. Collect all plastic containers, plastic egg cases, containers from airline meals, they come in invaluable, and are unbreakable.

SPONGES
Handbooks on water colour used to recommend real sponges for putting on washes. As it happens, they are still slightly preferable to their plastic equivalents. Sponges are also used for blotting out effects. Just as effective are tissues.

PAINT RAGS
For wiping brushes, these should at all times be only of cotton or linen.

TISSUES
The tissues that are sold for paper handkerchiefs are very useful for blotting out colour. Blotting out an area of colour you will find leaves a matt, rather agreeable surface.

EASELS
These, for water colour, are not essential. Most water colour painters work without one. You can save money by not having an easel. If you like the idea though, be quite

sure you get one that is efficient; that is, that the screws do not get stuck or all falls down at the least thing.

The basic equipment of water colour is very simple. Perhaps there is *no need to add that you can buy smart enamelled water holders,* but any plastic bottle with a screw top is just as good. Always, if you are going out painting, allow for more water than less, as there is nothing more depressing than trying to paint a delightful, fresh painting with dirty water.

I wonder how many of us received the urge to start painting from first seeing a water colour box in a shop. The clear, bright, shiny colours, almost like confectionery, so well remembered from childhood. Before you get carried away by these delightful boxes, however, it is worth taking thought about what your basic needs will be. There should be enough mixing space. Indeed, it is worth settling for a larger than a smaller box, if you are going to take any long term view of painting. The boxes you most usually see are already fitted out with colours, though it is a very good idea to buy a box and get colours separately of your choosing. Obviously, providing you have something to carry the colours, and space to mix paint on there is no need for any enamelled, manufactured paintbox (Fig. 67).

Water colours come in tubes, and in small square or rectangular containers, which are called pans. Both have advantages. If you keep all the paint tubes, only squeezing out what you need at a time, the paint will never get discoloured. Every lot you put out will be fresh and quite clean. Tubes of water colour must at all times be kept tightly closed when they are not in use, otherwise the paint will dry out in the tube and be impossible to get out, which is wasteful and expensive. Pans of water colour do not dry out, as they are mixed with less gum arabic and water. It is easier, however, to get the colours dirty when mixing from one colour to another, and care must be taken to keep the pans clean. If you do not have the opportunity to paint very often, pans are probably better. It is when it comes to the colours themselves that we have a great advantage over earlier painters. This is in the research that has gone into colour making, and the results are the brightness, clarity and permanence of the new colours. From colourmen's lists it will be seen that quite a number of water colours advertised

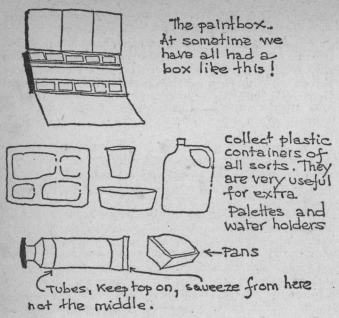

The paintbox. At sometime we have all had a box like this!

Collect plastic containers of all sorts. They are very useful for extra. Palettes and water holders

←Pans

Tubes, Keep top on, squeeze from here not the middle.

Fig. 67. Equipment

are not entirely permanent. As you may know, permanence is denoted by the number of stars a colour is marked by. Providing you do not expose the painting to strong light for stretches at a time, you can in fact use impermanent colours without ill effect. It does *not* follow that the less permanent colours are the less expensive. While you must make up your own mind, permanent colours are probably better. The list that follows may prove helpful, but of course you should at all times experiment for yourself. All listed colours are permanent. Water colours are either natural earths, metallic salts, or dyes suspended and ground in gum arabic. They dry almost immediately they are on the support, and so, unlike oil colour, you cannot very easily work into the colour once it is on the support.

In traditional water colour, white is not used, but, as a later chapter will be about opaque water colour using white and gouache, white is included.

The white sold by artists' colourmen for water colour

painting is Chinese White. This is a dense kind of oxide of zinc, specially prepared for water colour painting.

High grade opaque water colours are usually called Designers' Colours. The white in this range is usually listed only as white, though Winsor and Newton manufacture a Permanent White, and a Zinc White. Some other Designers' Gouache colours will be listed too.

A SELECTION OF WATER COLOURS
Lemon yellow
Cadmium orange
Cadmium red or bright red (W & N)
Alizarin crimson or permanent rose
Permanent magenta (W & N) or permanent mauve (R)
Ultramarine
Caerulean (sometimes spelt Cerulean)
Viridian
Sepia or raw umber
Yellow ochre
Light red

Some painting manuals would not have listed any orange, purple or even green, as they would give instructions on mixing them instead. This has an advantage in some ways, since such a limited range of colours means you do not go very far wrong, though you will never get true and clear colours either. As you will see in a later chapter, no orange, green or purple that you obtain by mixing ever equals the ones you get in the ready-made paint. If you are using designers' colour or gouache, you will need white as well. Black *is* difficult for a beginner; graduate to it later.

WATER COLOUR PAINTS

YELLOWS AND ORANGES

R = ROWNEY – W & N = WINSOR & NEWTON

NAME OF COLOUR	QUALITY IN WATER COLOUR	QUALITY IN GOUACHE
Lemon yellow Winsor lemon	Clear, brilliant, light. An indispensable. Cheaper than cadmium lemon.	Lightest colour next to white. Indispensable.
Cadmium yellow	A true middle-toned yellow.	Equivalent in designers' gouache is middle yellow or brilliant yellow (W & N)
Cadmium orange	A clear, true orange, of the finest quality.	Equivalent in designers' colours is marigold.
Naples yellow	Slightly inclined to opacity, as it is very near to white. Most useful for architectural studies. A traditional colour used by all the old masters of water colour.	A very pale almost neutral yellow. Very useful for mixing with other colours, and for architectural studies.

NAME OF COLOUR	QUALITY IN WATER COLOUR	QUALITY IN GOUACHE
Bright red (W & N)	An organic dye pigment, very bright almost to orange.	
Scarlet lake	Organic pigment. Very clear and bright, but when it is diluted over a certain amount it loses its character and turns pink.	A brilliant bright red.
Cadmium red	A middle red. Very useful, and loses none of its character in dilution with water.	
Alizarin crimson	The traditional deep red used by most artists. Turns slightly to brown in dilution.	The traditional deep red used by most artists.
Permanent rose	A beautiful and delicate pink in dilution. Not as strong as Alizarin crimson. Good for flower painting.	

BLUES AND PURPLES

NAME OF COLOUR	QUALITY IN WATER COLOUR	QUALITY IN GOUACHE
French ultramarine	A deep toned traditional blue, and indispensable. Complex combination of silica, soda, alumina and sulphur.	Vivid mid-toned, an indispensable colour.
Manganese blue (W & N)	Barium manganate. A very light turquoise blue. Good for skies and sea.	
Cerulean	Light blue, stronger than above, mixes well, and dilutes well.	The lightest permanent blue in gouache.
Cobalt blue	Cobalt aluminate. A mid-toned blue.	Very bright mid-toned blue; permanent.
Monestial (R) or Winsor (W & N) blue	An organic pigment. One of the darkest and most intense colours in water colour. Useful for mixing very dark neutrals. Dilutes in water to a slightly green colour.	The darkest blue. Very intense. Permanent.
Cobalt violet	Cobalt salts. Pale, somewhat granular in dilution in water.	
Winsor violet	A very deep strong violet, an organic colour, dilutes well in water. Very useful for mixing dark neutrals. A blueish violet.	Take care with violets in designers' gouache; some are impermanent.
Permanent magenta	Quinacridone colour. A red-based violet.	

Many traditional greens are still marketed though marked as impermanent. These are not listed in detail here. Any colour with less than three stars against it is of doubtful permanence. They are, Hookers Greens, Sap Green, Green Lake, Olive Green.

BROWNS, EARTH COLOURS AND NEUTRALS

NAME OF COLOUR	QUALITY IN WATER COLOUR	QUALITY IN GOUACHE
Yellow ochre	A neutral yellow made of a natural earth. A traditional colour and indispensable. Mixes well.	Permanent and essential to any palette. Mixes well.
Light red	A natural earth, a warm brick red. An essential on any palette. Mixes to make a whole variety of colours.	Rust red (R) or red ochre (W & N). An essential permanent colour. An excellent mixer.
Raw umber	A green based brown made of a natural earth. Very useful inl andscape painting.	A green based brown, pale in gouache.
Sepia	The traditional brown used by water colour artists. Now an organic synthetic dye.	Sepia (R) a dark brown, probably more useful than raw umber in gouache.
Payne's grey	A mixture of other colours. Neutral, and inclined to opacity.	Several shades of grey are manufactured in gouache.
Davy's grey	Made of crushed slate. Pale, warm.	
Ivory Black	Both blacks are carbon based. They are the darkest and most opaque colours in water colour.	Black of any description is much darker in gouache when it is wet than when it is dry.

There are even more colours listed in a colourman's list as permanent, and there is every reason to get them if they appeal to you. The ones described are those in the most use, and to start you off. Probably, while you are getting used to your equipment a limited number of colours is best to begin, and you can drop colours and take up others as you go on. In the selection of colours there is as wide a tonal range as possible.

GREENS

NAME OF COLOUR	QUALITY IN WATER COLOUR	QUALITY IN GOUACHE
Viridian	Chromium sesquioxide. A very popular colour, many painters find it indispensable.	Permanent, an excellent mixer.
Winsor emerald	Organic Pigment. A very high-toned colour, bright, intense.	A very brilliant permanent colour.
Winsor green	A very dark intense green, one of the darkest colours on the list. Useful for mixing to dark neutrals.	A dark, permanent cold green.

All the listed permanent greens above are cold in colour. By cold we mean that any colour tends towards blue, and warm is a colour tending to the red colours. All the listed greens can be made warm by the addition of yellows, and in some cases, reds.

STILL LIFE AND ABSTRACTION IN WATER COLOUR

It cannot be sufficiently stressed that the traditional English approach to water colour is still popular because it is in itself something to which so many painters find they respond. Water colour is transparent, and its quality is largely due to the way white paper shines through the paint. The more water colour is mixed the more opaque it becomes. By the traditional method, you do *not* lighten paint by adding white, only by adding water. Therefore to get absolute white you *leave the white of the paper*. Before starting any water colour you have to think, or make rough sketches, about what spaces you are to leave absolute white. Then you build up palest colours first, working through to the darkest.

All the old-fashioned water colour manuals give exercises in the methods of water colour handling for beginners. This is a good idea. To our late twentieth-century eyes these exercises look like abstract paintings, so why not try, to start with, some experiments in abstraction. All water colour manuals I have ever seen stress the need for training one's hand in the ways that water colour behaves. One could even write 'tricks' of water colour, but it is a bit more than just tricks, of course.

So to begin. But just before we do, a word about your equipment. At a week-end painting course, a student approached me in despair. The trouble, according to her, was that she 'couldn't draw'! In the circumstances it was scarcely surprising! Half the colours were squeezed out in any old order. The water was dirty, the easel kept together with string etc., etc. So begin by giving yourself a chance by organising your equipment. For the following experiments you will need several pieces of every kind of white water colour and pasteless board, hot pressed, not, wove, laid, heavy, medium light. Please, plenty of water. Enough working space, including mixing space. I hope very much that if you have painted before, all your equipment is clean after last time! Brushes, cotton rag, tissues and we can start.

A plain wash.
Try to paint the
colour on evenly.
← Your brush for a good
wash must be well
loaded with colour

A graded wash.
The paint is put
on dense at first
and then thinner.

Fig. 68. Washes – plain and graded

WASHES·

You will come across this word many a time in water colour (Fig. 68). With clean rags soaked in water, thoroughly wet the surface of a piece of wove paper. If the paper is about 6 × 9 inches there is no need to stretch it. Mix plenty of blue in water on the palette. With a largish brush, run the colour across the top of the paper, with a bit more water in your paint, with swift bold strokes, run the colour till it gets paler down the paper. Try the experiment again on thin laid paper. On both papers be certain to lay the paint on in decisive strokes, do not brush into the paint too much once it is on the paper. Compare the effect of a wash on wove and on thin laid paper. While the paper is still damp on both pieces, practise some brush strokes. Fig. 69 will show you how. Again try to leave the brush stroke once it is on the paper, as this is a very good discipline for making clean, clear, water colours. You could practise this several times, but for

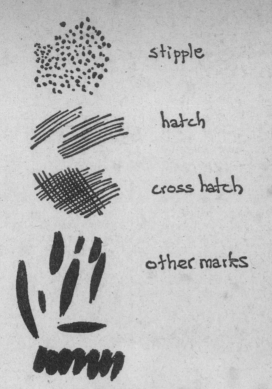

stipple

hatch

cross hatch

other marks

Fig. 69. Some brush marks

the moment, leave these aside to come back to later. Meanwhile, on two more pieces of moderately rough paper, Bockingford will do very well, damp one and not the other. On the damp one spread an even pale wash. On the dry, paint a square, and wash in everything else, leaving the area of the square white. Coming back to the dry first two washes, make brush marks on the dry surface. Try to feel the difference between working on a dry or wet surface. The feel of any medium through your brush, hand, and body is essential. On the second exercise, first lay the wash on damp paper. With a dry brush first and then a tissue blot out some colour; this is the nearest you can get to taking out colour. On the dry paper, keeping the white plain, add a darker

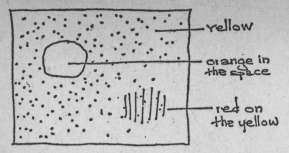

Fig. 70. An experiment with colour

wash. Now with a darker wash still, cover some of the ground and some of the white.

Make a series of experiments in getting to know each colour. Start with yellow on damp paper leaving an area white, as in Fig. 70. Add orange and then red. Do red and yellow equal orange? Add blue to see if you get a green. Repeat the experiment as shown, with all the other colours in turn. Try to get each wash on the paper as clear and even

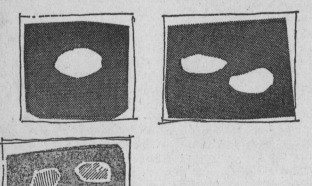

Fig. 71. Practise making washes leaving clear spaces. Fill in the spaces with the opposite colour

Fig. 72. With the colours described, paint lines leaving spaces between them

as possible. Another experiment with wash is to start by leaving out two white spaces, then three and more and more, on damp and dry paper. As you can guess, this is often a way of painting clouds, or reflections on water. At the other end of the scale are the dark colours. How dark can you make water colour? One can use black itself. (I admit, through training, a prejudice against black, but it you want to use it, do not let anyone put you off!) Try sepia or raw umber, fairly thickly. Next to it, a mixture of Winsor green and purple (or monestial and purple). Is the dark neutral darker? Try and mix a dark neutral as dark as you can.

Some experiments on darkening colours. Make a wash of green as shown in Fig. 71, leaving spaces. This is never an easy thing to do, but excellent practice! In the spaces paint a mixture in equal quantities of red and green. You have neutralised the green with its opposite colour. Now, with different kinds of brush strokes, darken areas of the green with blue and then brown. Repeat this experiment with other colours of your choosing.

Probably, in anticipation of our climate, the old water colour manuals give many recipes for grey. Here is an exercise you can do with them. Cobalt and light red in equal quantities make a warm grey. Wash an area of dry paper (any kind of surface) with the mixture. Very close to it, but leaving the narrowest white line, paint the same mixture as before but in greater dilution. Ultramarine and raw umber make a grey-based sort of green. Paint another area, leaving a thin white line of paper. Viridian and crimson for a grey. Leaving a thin white line is not at all easy, but it is another good exercise in training the hand (Fig. 72). If you have got some pasteless board, it is heavy and

excellent in quality. Of course it is expensive too, so experiment with quite small pieces, not larger than 4×6 inches. On a dry piece paint any colour. Now soak the board in a basin of water for about three minutes. The colour will spread, the board will be quite unharmed. Try the effect of blotting out with a tissue. One thing about very heavy expensive board and papers is that if a painting *does* go wrong, then you can use the other side, if it is clean.

I hope you are not getting too bored with exercises, but it *is* a good idea to have a pre-knowledge of how your water colour will behave. Unlike some other paints muddling on somehow is not helpful, and the mess gets depressing. If you are liking abstract experiments so much that you do not wish ever to do anything else, then so much the better. If you are longing to start figurative painting there are some more experiments worth trying.

One concerns greens. Paint all the greens you have, albeit the only one (possibly viridian) on your paper in patches. You will see that all greens straight from the tube or pan are cold greens. For this reason they probably look unnatural. Try mixing them all in turn with lemon yellow, orange and a drop of red, each of these in turn too, not all mixed up together! Mix the greens in turn with yellow ochre and light red too. They will, I think, begin to look a bit more natural. Old painting manuals and the early painters like Girtin have mixtures for greens. They used ultramarine mixed with any yellow or even umbers, or Prussian blue (not listed in Chapter 7, as monestial or Winsor blue are the same colour but better in all ways) mixed with yellows, ochre and umbers. Now this brings us on to the next exercise:

COMPLEMENTARY COLOURS

This is based on the theory that white light is made up of three basic colours, yellow, blue and red. If these colours in light are mixed (a science museum usually has the apparatus for the experiment) then you get white light. However, if you mix not light but pigment, the three colours mix up to brown. Further, in theory the following is so. Try these mixtures:

Red + blue = purple, leaving yellow as the complementary and the other way.

Red + yellow = orange, leaving blue as the complementary, and the other way.

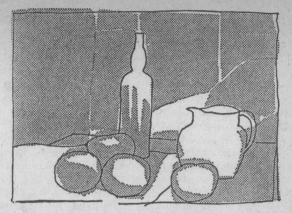

Fig. 73. Draw out a still life in clear unfussy lines. Put on the first wash. leaving spaces where you want white to be

Yellow + blue = green, leaving red as the complementary and the other way.

This theory is the foundation of Impressionist painting, and is generally used to create colours in shadows. Like a yellow dress with purple in the shadows. It is true that in certain lights it is possible to find more colours in shadows than in others. Colours in shadow liven a painting. If you are painting abstracts then a colour next to its complementary is enhanced. Many painters still like to use greens, oranges and purples for mixtures. As I pointed out in Chapter 7 they are rather dull compared to the colours now available ready made. However, if you like them, go ahead. These mixtures are, in fact, rather good for making shadow colours.

The most usual subject for beginners to figurative painting is the still life. It is not difficult to see why. If you arrange a still life in a studio it stays the same and you can do many studies. A still life can be of the simplest forms and objects by which to study light, depth, mass, shape etc. To begin then, arrange a very simple still life. Do not spend ages drawing it out on your water colour paper. Keep to the simplest lines (Fig. 73). Decide which is to be left white – it might be cloth or a piece of china, or a reflection on a bottle. Depending on the dampness of the paper you can add the tone colours by merging them into one and another, or by leaving a hard

sharp edge – or both. Be prepared to put the paint on in vigorous washes, and do not be timid. Very often what we admire most in a water colour is freedom of brush handling; it somehow suits the wateriness of the water! Do not be afraid of mixing substantial quantities of colour either. If a colour is too runny, you can blot it out with tissue. We have just mentioned shadows. In our Western way of looking at things, we see form through shadow. What colours and shapes are the shadows and where do they fall? You know by now that in water colour the more you mix the more you stop out light reflecting from the paper. Try where possible to avoid mixing, except by the simplest means. One way of mixing is by dropping the second colour into the first when it is on the paper (Fig. 74). Shadows give form but they give the tonal balance of a painting too. Then try another painting of the same subject, perhaps from a different angle. This time why not be really enterprising and try to paint without any pencil guide lines; or if you cannot face this, try painting guide lines in very weak paint. Do not worry if your first attempts are disappointing. Just go on, and start another. The idea of a still life is to have something unchanging in front of you to work at continually.

Cézanne is an example of an artist who painted water colour still life (and indeed in oil too) as explorations in composition and light. But of course, while this approach is valuable and helpful, there are other approaches that are just as valuable in artistic experience. There is the kind of still life of carefully chosen beloved objects, detail of light on surface being an important characteristic. In this case you would need a hot-pressed surface paper, an essential for detailed work. Earlier I stressed a broad approach to water colour, I happen to like it but there are many painters who, by nature, tend to compose a painting through the detailed vision. I do not want them to feel left out, so here are some observations. However detailed your work, it should hold together in tonality and concept. Detailed work implies a fine brush. Either you can work each layer of paint into the previous while it is wet or wait till it is dry. If you are painting into wet paint, try not to mess too much into the paint with your brush or the paint begins to look 'worried'!

Since Bonnard and Vuillard, the approach to still life – as you will find in their lovely water colours – is the casual. Or the seemingly casual. Food on a table, or potted plants lined

On to wet paper drop in points of colour. Use a well loaded brush with very liquid paint. The colour will spread into the wash

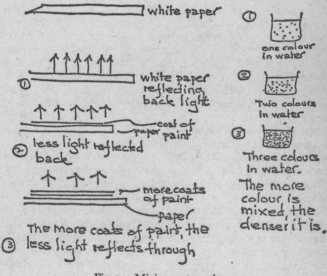

white paper

① white paper reflecting back light

coat of paper paint

② less light reflected back

more coats of paint
paper

③ The more coats of paint, the less light reflects through

① one colour in water

② Two colours in water

③ Three colours in water.

The more colour is mixed, the denser it is.

Fig. 74. Mixing water colours

on a sill or mantel shelf. How many delightful glimpses one can see like this in a single day! You barely have to move out of a kitchen (Fig. 75). Of course, once you put these chance delights into water colour on paper, all element of chance has vanished and your decisions are deliberate.

Fig. 75. You need not even move out of the kitchen!

Marvellously, a few objects can record a whole mood or situation. But you should take stock of your work as you go. Are the shapes working? And the tones? There is nothing more depressing in a painting than when the tones are all even. Of course, you can always darken where needs be, but not lighten.

For abstraction, the first and foremost painter to look at is surely Klee, and then his contemporary Kandinsky. Obviously, most painters have used some kind of water colour during their working life, but I am rather stressing those to whom it was a particular means of expression. It is particularly popular in America. Sam Francis uses it to make beautiful abstract paintings. So does Henry Miller, the same Henry Miller who wrote *Tropic of Cancer*. His favourite water colourist is Turner. Miller said that one thing about water colour is that it does not matter if you make a mistake, you can always do another! An encouraging note to draw the chapter to a close. Then there are the water colour still

lifes of Cézanne, Bonnard and Vuillard. As well as famous names, do look out for paintings by lesser known artists, for whom water colour is such an ideal means of expression.

After a painting session – clean your equipment!

Look at water colours by:
Paul Klee, (1879–1940)
Sam Francis (b. 1923)
Mark Tobey (b. 1890)

LANDSCAPE IN WATER COLOUR

Some of the finest water colours ever painted have been of landscape, and architecture. In this chapter we will look at landscape. Landscapes, and we can reasonably include seascapes, are painters' visions and interpretations of the external world. Vision is impossible without light, and light in nature is inseparable from colour. The mainstream of twentieth-century art has barely included landscape. A personal interpretation of nature scarcely comes in to the world of international exhibitions, magazines, and fashionable paintings that are much the same from Tokyo to New York.

This is, in fact, the best possible reason to paint landscapes. In the face of international art one is inclined to forget the really excellent individual painting that is being done by artists, especially in water colour, who are so easily overlooked. Technically the joy of water colour is that it is light, and clear, and you can capture the fleeting effect. Beyond what is purely technical, the value of water colour is that it is personal, and, if you want it to be, it is private. You can achieve something entirely personal that is no one else's, painted quickly in a moment of time, when you are doing quite other things. Browsing in antique shops, one often comes across folios of paintings in water colour painted by amateur artists. Sometimes they are not very good, but one is always glad they were painted. They tell you something about what a place was like, as well as something about the painter. Above all, these paintings were somebody's feelings about a place at a certain time, and whatever the artistic quality of the painting, some feeling that was worthwhile comes through.

Many water colour painters carry their equipment in a canvas satchel, or some sort of holder. Whatever you carry your equipment in, it is a good idea to attach a list to it of *all* the things you will need. There is nothing more irritating than going on a painting expedition only to find that you have forgotten some paint brush, or a colour. Be quite sure

Fig. 76. Look in landscape for *direction of light*. It makes all the difference to tone and colour

you have enough water. As you should have discovered by now, dirty paint water means dirty colour. Large plastic containers are readily obtainable, and are very useful for carrying water.

It is always as well to start by making some sketches, to get the idea of the subject you are painting. Drawings for paintings clarify your thoughts. You could draw in a separate

little hand sketch book in pencil, or, better, in brush and sepia. The latter method will accustom you to using the brush and to sort out tones. If you are painting in a rapidly changing light, perhaps on a windy day with scudding clouds, do not bother with preliminary drawings, and go directly to your painting. Look carefully to see in which direction the light is coming, as this will affect the shadows (Fig. 76). The direction of light is something of which one is peculiarly conscious in the north, though it is not as apparent in the Mediterranean. The direction of light is what gives landscape its chiaroscuro, which Constable believed was the unifying factor in landscape. Despite the theories of Impressionism, which has led many a painter to paint northern landscapes with the blue shadows of Cézanne's Provençe, Constable's observation is still entirely relevant to English light, though, of course, if *you* in fact see blue shadows or shadows in any other colour, you must paint them.

To begin, do not draw too much in pencil on the water colour paper. Very experienced water colour artists do not outline in pencil at all. If your paper is stretched or in blocks, touch it very gently to feel if it needs to be soaked again. It is not easy to start a water colour on very dry paper. Then you should know the next rule, fundamental to all traditional water colour: leave spaces for the absolute white. Where in the landscape are the absolute whites? Likely enough in clouds (Fig. 77), or in light reflected on water, or a building.

Try not to be timid with your first strokes with the brush. Some painters use as the next lightest colour to white an all-over colour to give the water colour unity. Try this at some time. If it does not work, then unity must be kept by the drawing. The French, as you know, have a very useful word for drawing – *dessin* – which implies the element of design that should be inherent in any good drawing. To go on then, simply enough, you add the next lightest tone of colour. When you are new to water colour, it is very easy to be intimidated and to use small brushes, taking care over details. Some painters by nature compose paintings by the sum total of small details, it depends on their way of seeing things. Even if you want to, for the moment try to do your first water colours using larger brushes, attacking the subject

Fig. 77. Leaving spaces for absolute white

boldly. Use plenty of water with your colour. Be sure that the parts of the paper that are waiting to have paint on them are not drying out, damp them every so often, with very clean rag, or a sponge dipped in water. If you have painted where you did not intend, you could try and mop out all you can while the paint is still wet. There is not much chance of being able to once the paint is dry.

So far, I have resisted touching on the subject of oil painting. Otherwise it might lead to all kinds of discussions about comparative merits. Of course, the two methods cannot be compared and one uses any medium on its own terms. However the very nature of water colour has one point of contrast. In a slow drying, often opaque medium like oil paint, or for that matter acrylic, you can overpaint, scrape down till it is right, sometimes to great advantage. As you will have found out, this is not possible in water colour. So, whereas it is good training sometimes to work on and on at an oil painting, however badly it is going, you can leave a water colour just at the point when you think it looks right, without feeling any compulsion to go on. If, by bad luck, or just inexperience, a water colour goes wrong, you can also learn quite a lot by taking it as far as it will go. Or to be more precise, as long as the paper will stand being painted.

At first, you cannot expect paintings to go well the whole time, and if they go badly, there are two cures. One, to paint another picture at once! The second, to have a look

Fig. 78. Some sketches of clouds
1 Cumuli with the light shining on them
2 Cumuli with the light behind them
3 Alto cumuli (always conspicuous at sunset)
4 Cirrus (mares' tails), a high-up cloud

at the painting and assess where you went wrong. The paper
may have been too wet, and the colours run into one another.
Or the paper too dry and the colour not have taken. One
part of the painting may have carried you away so much that
it has distorted all the rest. Detail is important but relevant
detail is what one must seek. Some landscape paintings get
into difficulties because there is a conflict of interest in the
painting. One takes stock of the painting and there are
several things competing for the main area of interest.
Certain kinds of composition distribute interest equally. At
other times you have to make up your mind what the paint-
ing is about most. There are many times when I have
painted water colours and there is a conflict between trees
and skies. It is worth considering these, as they are so basic
to landscape. Look to see where the light is coming from,
as this will affect the colour of clouds, See how clouds mass
and separate. Clouds will affect the colour of the whole
painting, as they affect the light (Fig. 78). Every discussion
brings us to the inter-relation of colour and light.

elm

beech

oak

horse chestnut

Fig. 79. Some diagrams of well-known trees. The dotted lines show the growth of leaves, their silhouette in summer

Trees are not difficult, as the basic anatomy can be readily learned. This will give you a framework to order your seeing. No framework or any system to order your perception of appearances should be used when it becomes a formula. This means that you have stopped looking. The main problem with trees is that of leaves in relation to mass and form (Fig. 79). Once I saw a water colour of a tree with every leaf, or so it appeared, accurately painted. But the sum of this did not add up to a living tree. Naturally, this problem does not arise in winter, when the chief delight of painting trees is the beautiful silhouettes of the branches. These are endless subjects for compositions. Be particularly

observant about the colour of trees. Many, in damp places in the winter, have trunks that are quite green with mould. Look carefully at the colour of trees in the distance. While one's mind knows that they are dark, the evidence of your eyes may tell you differently.

During any painting session be prepared to make several water colours, preferably on different types of paper, as the paper itself will condition the kind of painting you will make. The advantage of making several paintings is that some you could work on further, away from the subject. Some painters find that they can work better away from the subject after a while, as the idea of what the painting should be is more clear. Other painters cannot do this at all. You should try, when you begin, both ways, to see which suits you best. Not only can you paint into a picture away from the subject, you can also make the following experiments:

If the painting is on very thick paper or board, try soaking it in a bucket of water. Some of the colours will wash away leaving a stain. Take the paper out, and see if you can use some of the accidental effects to advantage. This is a particularly useful technique in seascape and clouds, but you do have to start with thick rag paper or pasteless board. Thin paper will of course fall to bits.

As you get to know your equipment, you will start to form your own favourite papers, colours and brushes. This is just as it should be. At first one may be disappointed by one's first efforts, because one's imagination led one to expect something that the paint and paper cannot in its nature do anyway. Remember, it is better to make mistakes, and have difficulties at the beginning. If success comes too easily, one will get careless. If you work slowly, or have a large number of failures before anything good comes, this is also an indication of the sort of painter you are, and it may be that the bad paintings are part of your creative process of painting the good ones.

In the British Isles, one associates, very vividly, certain colours with each season. Most landscape painting will be undertaken in the summer months, or thereabouts. A noon-day light on a sunny day makes for short shadows, and is inclined to take the colour out of the landscape. We are all familiar too, with the way the very bright greens of May and June seem to become heavier, or dry out, as the summer passes into autumn. Chapter 7 on colour pointed out that

all the permanent greens are blue-based, or cold colours. In some lights, greens in nature will incline to blue, especially in some shadows. Suggestions are given for making some warm greens. If you mix these colours you will be able to make enough to keep for other times. If you prefer to paint them on in layers, where you can make more unusual variations in colour, the lightest colour must of course be painted first, hence the lightest colour is listed first.

Lemon yellow + emerald = a very brilliant green, high in tone. Use with care as it can completely dominate the other colours.

Lemon yellow + viridian = a vivid green, very transparent.

These mixtures assume that you are using equal quantities of colours, though if you use:

Lemon yellow + a small amount of Winsor or monestial green you can get a very vivid green. It will become a very rich green with a touch of orange.

Orange + Winsor or monestial green makes a very rich dark green.

The traditional painting manuals from the early nineteenth century all give directions on how to make greens. Some of these are now impractical as they contain obsolete or impermanent colours, though it is possible to get their equivalents. Mixed greens are not as clear or true as the pigment itself, but they are very useful for shadows and distances. All colours lose their brightness as they recede from the eye, so the following mixed greens can be very useful. Assume that the quantities are equal unless stated to the contrary.

Lemon yellow + cerulean or cobalt blue = the lightest mixed green you can make. Very useful for moderating a bright green.

Yellow ochre + ultramarine = a very dull green.

Orange + ultramarine = a richer version of above.

Lemon yellow + violet = a very unusual colour, almost like khaki.

Raw umber (or sepia) + Winsor or monestial blue = a dark greenish neutral.

By the laws of complementary colours, greens in landscape should reflect red in the shadows. It always gives life to a painting if the shadows contain some colour, not just darks. It is likely that you can see the opposite colour and

Fig. 80. A way of making brush strokes for several colours. Useful for shadows which contain many colours

the neutral of the same colour in any one shadow. Fig. 80 will show you how to paint them both, using the technique of Seurat. It has been known by artists for many centuries that distances appear blue, with colours losing their brightness. You should not, however, rely on painting a distance just in blue, without using your eyes to see what colours, or modification of colours, your own eye finds. Rules are only given as guides – as long as you need them use them, but do not hesitate to make rules for yourself according to the needs of the painting and what the evidence of your eyes tell you.

The Expressionist painters used colour to express mood. These painters worked in Germany before the First World War. Some art historians have seen this movement as an aftermath of the Romantic movement of the nineteenth century, which produced some of the finest landscape in European painting. Landscape and colour both express mood, and we often enough, like the Romantic painters and poets, find response to our inner state of mind in contemplating nature. The word Romantic is used here, of course, in the technical sense to mean the specific group of painters and poets. Landscape in the northern countries has considerable change of mood and season, and it is likely that we have a whole set of colour moods for each season. So, now let us think about winter landscapes.

The sun never rises very high in winter, so you do not see nearly as much light from the sky as in summer. You will also observe very long shadows. Because there is considerably less green, and more bare earth, in general the land will be very much darker than in summer. By soaking your paper, and painting washes of blue and violet, you can get the most delightful effects of mists. You can also soak your painting paper, paint the colours of mists and clouds and then paint

122

Fig. 81. In a snowy landscape, the white is the lightest part, being even lighter than sky. Leave the white of the paper for the snow

into that. Snow, when one is lucky enough to find it, poses the problem of leaving patches of white paper and painting round the areas of white. Snow will be lighter than the sky even, and you may have to darken the other tones slightly to show up the full intensity of the white (Fig. 81). If there is an overcast sky, the light will be dull and even, but if the sun is shining, you will see very clear blue shadows.

Here are some further suggestions for mixing colours. Some are adapted from the landscape painting handbooks of the last century.

For greys, in clouds and distances (as always, the lightest colours are given first):

Light red + cobalt blue = a warm grey.

Light red + ultramarine blue = a rather inky grey.

Viridian and purple = a purple neutral grey.

Naturally you can also make grey by using black with enough water. So far the use of black has not been encouraged. It is a very drastic darkener in water colour, and has to be used with great care. Otherwise it can so easily get into every other colour on the palette and make for very dead colours. This is only a personal opinion on black and, of course, if you want to use it, you must.

A neutral grey like Davy's Grey can be coloured slightly with any other colour to good advantage.

The melancholy browns of landscape, and the dull greens,

123

are delightful in the winter. Some suggestions for mixing them:

Light red + purple + ultramarine = a red brown.
Raw umber + purple = a neutral warm brown.
Orange and raw umber = a very warm brown.
Viridian + light red = a mid-toned warm brown.

There will be times, as on holidays, when one may be painting in a southerly latitude, where the light is more constant. The general rule is that you can expect to find the same light effects day after day, at the same time. As the great French-Roman painter Claude discovered, the light at noonday is so bright that the colours disappear. The immediate implication for the water colour painter is the fact of the paint drying as soon as it is on the paper. The paper will, of course, have dried out from its stretching too. There are ways of overcoming this, such as starting with really wet paper, and using a sponge to keep the paper wet while you are working. The other course is to adapt your way of painting to these conditions. This will mean there is no working into wet paint, or colour spreading into damp colour. The advantages are those of being able to paint very clear well defined shapes. Look at the water colours of the American painter Winslow Homer, who painted in the South Seas. His water colours are all too little known in Europe. I have only seen reproductions, but they show the most vigorous, clear drawing with tones and shapes. Some very beautiful Impressionist water colours have been painted in the South of France, especially by Renoir and Cézanne. Clear paintbrush marks, building up the forms, are very suitable to the Impressionist method of analysing light and colour.

Instinctively, one feels that sea and water are natural subjects for water colour. This is not as absurd as the literal interpretation might seem, for it is possible to splash, soak, saturate, and dip water colour on to paper, in the imitation of the way water wants to go, and so obtain very good images of water. Raoul Dufy, a French painter of this century, is reported as having said that he liked colour because he liked splashing the water about! If you look, as you will probably want to, at some of the water colours of Turner, it is certain that this is how he made his almost miraculous studies of sea and sky. No one is suggesting that if you just splash paper with colour you will paint like

Fig. 82. Use a splashy technique, as it is nice to do in water colour. But do not *over* do it!

Turner. It *is* suggested, however, that in the painting of sea and water you can be very enterprising in your techniques. It surprised me to discover that Turner is the favourite painter of a very different personality, the American author, Henry Miller. He once said about water colours that it did not matter if they went wrong, as it is only a matter of painting more! It is very likely this is the way that Turner painted, throwing away those studies that did not come right. Some of his studies of sky and water are at the point of pure abstraction, and foreshadow the American Abstract Expressionists, whose works are known to Henry Miller. Looking at Turner's later water colours it is easy to forget that his earliest years were spent making the most accurate studies of architecture, which were a most exacting training in observation. Turner succeeds in keeping a balance between the soundest observation, and the most brilliant imagination in technique. Perhaps you are wondering if you should train your technique before you learn to see, but in the reality of painting they are inseparable (Fig. 82). So to begin painting . . .

Your paper will be soaking wet. Like one of the greatest water colour painters of all time, Tom Girtin, you should lay in your sky first. A contemporary of Girtin's recorded that this is how he began, and wrote further, 'They [the skies] were always remarkably luminous. Sometimes he uses warm tinted paper. He so mixes his greys, that by using

Fig. 83. Ways of making brush strokes to look like (*top*) light on water and (*bottom*) waves

them judiciously they serve to represent the basis for every species of subject!'

The sky then is established. To quote Constable, 'the sky is the source of light in the picture and governs everything.' Certainly, in seascapes the mood of the sky will always be reflected in the sea. Will the sky merge gently, almost imperceptibly into the colour of the water? Or, will there be a hard bright tonal colour difference, like you see in Cornwall and the South? If there are lighter parts of the sea they should be painted first. There might be problems of the white crests of waves. It is rather a problem to paint round them leaving the spaces (Fig. 83). Ruskin describes in an account of Turner's methods that he would scratch out the white in waves with a very sharp knife. This can be done if you are using very heavy paper, or pasteless board, with excellent effect. It may seem that there are a lot of tricks of the trade to be learned in water colour. It is reasonable to use any tricks you please to get a good result. It only becomes a bad painting when the tricks are used for their own sake, and the onlooker becomes conscious of them only, and does

not see the painter's vision. Ruskin goes on to describe how Turner also took the highlights out of the wet paint with a brush. We know too that Turner would paint on wet, thick paper, and then soak the painting in a tub of water to get his effects of mists, sunsets and light on water. Sometimes, when you look into a Turner water colour you can see that he has painted again into the picture to make use of the accidental. The possibilities of sea could be explored almost indefinitely in variations of the simple composition, though there are variations, too, which will include the foreshore, boats and figures (Fig. 84). Take care, when you are painting boats that they are 'in keeping'. It is worth explaining this phrase. It was a quality that was particularly valued by the eighteenth and nineteenth century painters. It means the tonal values of the subject being painted. Indeed, what would come out in a photograph, and, by training, what we interpret as distance and form. Tonal relationships are basic to good painting of all kinds, figurative and abstract. Colours cannot be considered without their tonal value.

To return, however, to the subject of painting seascapes and boats. If the boats you have painted are out of keeping, it will distort the whole painting. See that they are to scale. The scale of any man-made object has a distinct effect on landscape painting. Turner used to paint very small figures and boats etc. to give the feeling of the vastness of landscape.

If you study John Singer Sargent's truly brilliant water colours of Venice, you will observe that he makes the water by drawing the waves with a semi-dry brush on almost dry paper, giving an effect rather like chalk. His pictures give the impression that they were painted with great speed. It is probably a good idea to paint the ever-changing light on water as quickly as you can. Do many in one painting session. Try working on them away from the subject. Some painters find that to do this with water colours kills the spontaneity. Unfortunately, I cannot give you any definite directions on this, as it is so personal that you can only find out by trying for yourself.

There are so many beautiful, harmonious and contrasting colours that are suitable for painting sea and sky, that it is well worth experimenting with them yourself as a problem in abstract painting, just for the enjoyment of using blues, greens, purples, etc. mixed, plain, and in many degrees of tonality.

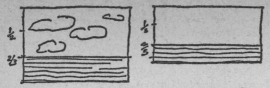

The most basic composition for sea
is simply — what proportion of picture is
sea, and how much sky?

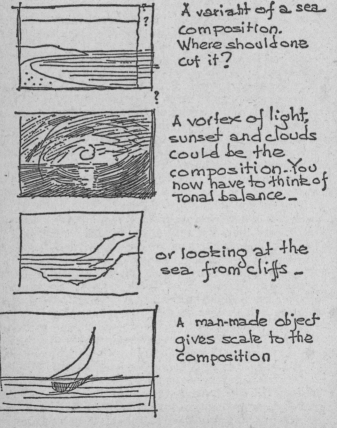

A variant of a sea
composition.
Where should one
cut it?

A vortex of light,
sunset and clouds
could be the
composition. You
now have to think of
Tonal balance —

or looking at the
sea from cliffs —

A man-made object
gives scale to the
composition

Fig. 84. Sea composition

Here are some ideas to start – as always the lightest colour is first, in case you are mixing or painting in layers. If you are painting in layers, vary the intensity of the underpainting for unusual effects.

If you have Winsor violet and viridian among your paints, they combine to produce a good neutral blue. The nearest you can get to turquoise blue is with manganese blue and a touch of emerald green. Try increasing the intensity of any colour by putting it next to its complementary. If you look at the sea in sunshine, it is possible to find the complementary colours reflected. In the same way, if you are painting the reds, oranges and yellows of a brilliant sunset, clouds and sea will reflect complementary colours. Sunset skies are splendid subjects for painting, and you should take great care with the tones. It is easy to get so carried away by the colour that you may find that you have a sunset with nothing in relation to it. In this case, it might be even as well to start painting to Corot's suggestion. Corot was the French nineteenth-century painter, and a master of landscape. Quite contrary to the rules I have explained, he suggested one should begin a water colour with the shadows and the darkest parts. It is worth trying, but remember, you will *not* be able to make the darks lighter!

Until now, the assumption has been that the approach to landscape and seascape is in terms of finding a view, and painting a comparatively formal interpretation. This is traditional in approach, dating from the eighteenth century when agreeable views of landscape were the framework by which people saw landscape, and possibly all that was meant by nature. It is just as much part of water colour painting to see that the intimate and the chance small vision are in the very nature of the medium. The very things one can see in passing that make one feel one wishes to capture a small moment of light, or colour or atmosphere (Fig. 85). The idea is to abandon wishing you could, and to try and make the wish a reality. It is better so have *some* sort of painting, than merely the idea in your head. If the reality turns out a bit of a disappointment, go on to the next; it is only by going forward you will do better paintings. We are probably much more familiar with the intimate water colour than we think. One often sees old-fashioned paintings of flower gardens that evoke a whole age. It was fashionable for years to despise the sort of paintings one can find everywhere of flower gardens

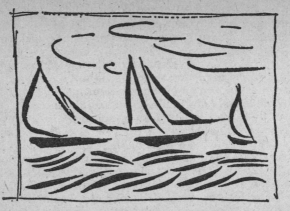

Fig. 85. The way you make paint marks can give the idea of speed. Paint marks should go more or less in the same direction, painted quickly and surely

and cottages. Whether their return to grace as a 'camp' following is any improvement, is difficult to say. But they are personal, and express very valuable sentiments, and this is what matters. The subjects for the intimate water colour are in front of you, providing you have the eyes to see them. The greatest painter of landscape, Constable, had the most clear eye for the intimate. His universal intelligence could take in flowers growing out of walls, details of fences, etc. Look at some for yourself.

In the words of the Impressionist painter Berthe Morisot about her water colours, 'all I aim to do is to try to fix some fleeting thing ... oh something – the smallest thing – a smile – a flower, a fruit.' You need never use large pieces of paper. This is the kind of painting that can be done at any time; if you were determined enough you could even paint a small water colour, not much bigger than about eight inches by five, every day (Fig. 86). Many people write a journal in words every day, though they would not find it easy to say what compels them to do so. It is probably a basic form of being creative and this could as easily apply in terms of painting as writing.

But to come down to practicalities: if you are inspired to paint on the impulse, and in small scale, a smoother surface paper is to be recommended, especially if you are working

Fig. 86. A corner of the garden

to a small scale. Rough surfaced hand-made papers or pasteless boards are better on a large scale. Some of the mould-made hot-pressed papers described in Chapter 7 are very suitable, also quality cartridge papers. As you will remember, the smaller the area, the less you need actually stretch the paper, though you may have to damp the surface, to ensure that the paint will 'take'. While you are making small intimate paintings it is a good idea to experiment with new techniques, and even colours too. You could try one painting using only a very thick brush to give your hand breadth – or only a fine brush if you feel you need practice in detail. Some painters, indeed whole schools of painters, like intimate details, though do not let attention to small detail stop you from being accurate in your drawing. Another experiment you could make is to repeat, as in the last chapter, painting objects leaving an outline by means of the white paper showing through. This can give the most delightful impression of light shining through, for example on flowers or leaves. It is used with great ingenuity by the American water colour painter, Prendergast, who like many other very excellent American water colour painters, is all too little known in this country. The eighteenth-century English painter Alexander Cozens wrote a most unusual and original book on water colour painting by blots. The blot was a mark in water colour. Rather than being something from nature, the blot suggests to the artist ideas for paintings. Alexander Cozens quotes in this context Leonardo da Vinci's famous advice in his note books to see mountains and land-scapes in stains and marks on walls. Sometimes you should

let the very nature of the paint tell you how to take the painting further. Of course, if you read another equally distinguished water colour painter, David Cox, on water colour he says quite the opposite, 'the picture should be complete and perfect in the mind before it is traced on the paper'.

Far from confusing you, however, such contradictions should be an encouragement, as there are so many ways of approaching painting. At first, it does not matter one bit if you take ideas from all kinds of different artists. Becoming a creative artist at any level is almost an organic growth. You take grafts of all kinds, you have to prune. The growth may lie dormant, but in the end there will be a growth that will be entirely your own form of expression.

Before the chapter closes, here are some more practical suggestions:

For landscape. If at all possible, do several studies of the same view, in different lights – morning, afternoon and evening. Also paint a series of the same view at different times of the year. A good idea to try a night painting too. This presents practical difficulties unless you can conveniently work from a window of a car or a house. In any night painting the whole range of tonality has to be very low in key. Neutral dark blues will be the basic colours. Painting the same landscape at different seasons and times will train your eye in seeing the general characteristics of the times and lights. The light will show you form, that is depth and solidity. By light we see colour, and what we put into words for convenience – light, tone, form and colour – are in painting indistinguishable.

For seascape. Try the experiment above, if you can. If the sea is miles away, here are some exercises that could be useful enough for any other subjects, but were inspired by the sea. Make marks with paint in plenty of water to suggest several kinds of movement.

For intimate and fleeting studies. The value of these studies will be very much increased if you have your sketchbook with you as often as you can manage. You might even consider having a miniature water colour box. Working quickly could accustom you to the very useful practice of painting without a drawn outline first, or of drawing in brush first. Much of this chapter has been biased toward the idea that landscape, with open views and distances, is

Fig. 87. The intimate view for a water colour landscape

available to everyone. Sadly, though, such is all too seldom the case except on holidays. This is where a more intimate approach is relevant. The late Eric Ravilious, whose death in the Second World War was such a loss to British painting, did one water colour of a London back garden. The sort of landscape that is in everybody's common experience. There are distant trees that one might see from a top floor window, an inexhaustible world that is right in front of you!

You could paint the small and wonderfully intimate world of your own garden, recording it, perhaps, in every season. Then there are views suggested through half open doors (Fig. 87). You can create your own world through water colour. I have mentioned the idea that painting in water colour is in some ways rather like keeping a journal. I think this is worth repeating. The world you record is your own visual interpretation. Then, from a practical point of view, what a splendid discipline for your work: the merest sketch done as often as possible will train your eye in seeing. You could set yourself different exercises every day, in colour, technique or scale etc.

My final advice in every chapter is: clean your equipment!

PICTURES TO LOOK AT

Here we have such an abundance of beautiful water colour artists, great and lesser known, that it is quite difficult to know where to begin! Wherever possible, however, *try and see the originals*. Reproductions should only be consulted when there is no chance of seeing the real paintings. There is a tendency nowadays to become so conditioned to slides and prints that originals are 'let down'. Where you will certainly have to consult books or reproductions is in the case of the American water colour painters. Winslow Homer and Maurice Prendergast have been mentioned, and so has John Singer Sargent, though there are some of his paintings in England. Many of the beautiful water colours of French and German painters will have to be seen in books. Particularly look out for Delacroix, Manet, Renoir, Harpignies, Cézanne, Van Gogh, Bonnard, Segonzac. I repeat, however, that *any* original is better than a print, so you should go to your local museum to see what you can find. Another source of water colours, again in reproduction but worth seeing, are the illustrated books of the Edwardian age. These books were produced when colour reproduction was just invented. Their style of water colour is slightly out of fashion, but I hope not for long as the paintings are deserving of attention.

Here, for you to look out for, are the names of some of the great traditional water colourists:

Paul Sandby, 1725–1809	R. P. Bonington, 1802–1828
D. Cox, 1783–1859	J. R. Cozens, 1752–97
J. M. W. Turner, 1775–1851	J. S. Cotman, 1782–1842
J. Varley, 1778–1842	F. Towne, 1740–1816
Peter de Wint, 1784–1849	John Constable, 1776–1837
Samuel Palmer, 1805–81	Samuel Prout, 1783–1852
Hercules Brabazon	Clarkson Stanfield, 1793–1867
Brabazon, 1821–1906	J. A. M. Whistler, 1834–1903

The clear technique of the very early water colour painters was to some extent revived early this century, particularly by Wilson Steer (1860–1942) whose water colours place him among the greatest. The following artists' work can be seen very easily in many local museums and galleries.

Sir George Clausen, 1852–1944	A. W. Rich, 1856–1921
	Eric Ravilious, 1903–42

Among living painters in water colour are:

R. V. Pitchforth R.A. John Nash R.A. (b. 1893)
 (b. 1895) John Ward R. A. (b. 1917)

The following painters from France, Germany and the U.S.A. are more usually associated with oil painting but their water colours are of great beauty, and should be looked at in books and when possible in the original.

Paul Cézanne, 1839–1906 Paul Signac, 1863–1935
Auguste Renoir, 1841–1919 Winslow Homer, 1836–1910
Maurice Prendergast, 1859–1924

And we must not forget the founder of all landscape water colour, Albrecht Dürer, 1471–1528.

PORTRAIT AND LIFE

In water colour one probably thinks of landscape and architecture as suitable subjects for brush, water, and colour before one thinks of portraits. By tradition, to grapple with the basic character of a head, or the forms of a nude, one would need the kind of medium which would take extensive developing, like oil or acrylic. However, there are aspects of the portrait and figure that are very sympathetic to treatment in water colour – especially movement. I am thinking of the beautiful life sketches in water colour by Rodin. In these tinted pencil sketches of the female form, it is as though the water from his brush were anticipating the molten bronze pouring into the mould.

In this aspect of the study of the nude, the rhythmic and the fleeting, then water colour is delightfully responsive. It is an excellent way of training your eye to see the body as a complete thing in itself. This is not as obvious as it sounds, for it is easy enough to make a drawing from life that is a mass of half digested knowledge – it is the body's unity that presents the difficulty. Looking, as you should, at Rodin's studies of the nude figure, you will see that the technique is quite simple. He has used a very clear pencil outline which he has filled in with washes of the same colour all over. Sometimes Rodin blotted out the highlights while the paint was still wet. One does not pretend that Rodin was not an artist of great experience and skill; and what looks so effortless in his work is the result of this. But it is worth making these sort of life studies to train one's eye whatever the outcome.

So to some practical advice. First, that of a model. Of course, it is very likely that you will be attending a life drawing group or sharing expenses of a model with a group of friends. Every so often or at the end of a long session of drawing, ask the model to take quick poses. These should be of about ten or fifteen minutes. In a quick pose the model can take positions that would be uncomfortable for a longer period of time. This is when you can do quick tinted sketches.

Try, although it is not easy, to get, in a few strokes, the whole of the body, its movement and rhythm. Indeed, you could start to brush in colour straight away. If you think you will be making many alterations then you should start with a pale colour. Blue is a good colour for the line drawing and so is raw umber. The paper can be wet or dry, depending on the size you are working. Then the flesh colour can be washed over the line drawing.

To mix a flesh colour:

Light red mixed with varying amounts of water alone, with no other colours can work fairly well, if you are in a great hurry. If you are painting on damp paper you can take out the highlights with a tissue or cotton rag.

For more subtle tones and colours the following basic mixtures of colours will be useful. They are intended as a guide, and with experience can be varied. The colours in each mixture can be varied in proportion, or made lighter with more water. It is assumed that the shadows will be made by the preliminary drawing, if it is drawn in brush in colour.

For a dark skin: light red + raw umber + yellow ochre.

If you are adding darker shadows to give more form, then you should look for blue and purple colours in the shadows.

For a yellow skin: yellow ochre + a little light red.

The illustrations of the body in movement (Fig. 88) have been done specially for this book by the sculptor Nigel Konstam, who, like Rodin, is a bronze sculptor, and is particularly concerned with movement and unity. Equally you could do a water colour sketch first of the figure in movement, and add the line later. But at all times remember you are using water colour in its own right, not just to colour a drawing that is already heavily worked in pencil. It has been said that Renoir painted his enchanting roses and peaches as a sort of practice for flesh tints in his oils and water colours. Water colour is admirable for the more delicate colours of skin. To effect this delicacy, do not over-work your painting. It would be difficult for a beginner to paint a spontaneous nude in water colour, so it is a good idea to practise drawing the subject on quite ordinary cartridge before you begin to paint. As well as the form of the body, draw the tones.

Work off your mistakes on your trial drawings. Then you

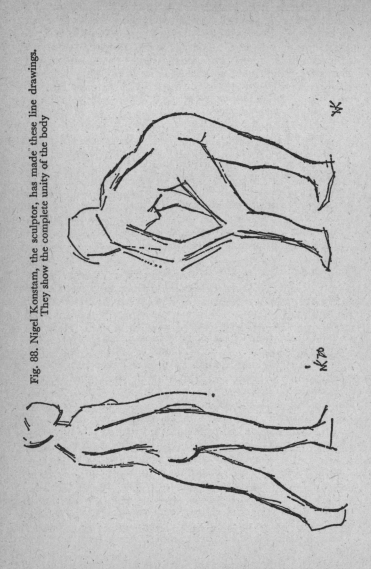

Fig. 88. Nigel Konstam, the sculptor, has made these line drawings. They show the complete unity of the body

can go clearly and confidently to painting the figure. By association and tradition the figure is more 'difficult' than anything else. But if you are nervous and worry about little details and lose sight of the main areas, you will find more difficulties than if you approach the figure as you would any other subject. Many of the complexities of painting the nude have been made by treating the nude as a stern object of relentless study. Not nearly enough attention is paid, especially in art schools, to the nude as an object of pleasure to the eyes, and through the eyes to the senses.

To come back to the painting. As in any other subject let the paper shine through the washes of paint. It might also be a good idea to pose the model against a background with some white, like a sheet, by which to grade all the other tones and colours. In this case look for purples and greens in the shadows. For white skins a basis of yellow ochre is a very good starting point. Cadmium red or light red can be added. For particularly fair skins you could use a base of lemon yellow and add crimson or rose or cadmium red.

If one were prepared to take care and time it is of course possible to make a study of the nude in traditional water colour. There is always something to be gained from a life study, so for this reason alone, a long life study in water colour can be recommended. But of course, you cannot work over your mistakes or take them out as you could in an oil painting. If you want to try, here are some suggestions:

Paint the general area of the flesh tone in first, very pale. While the paint is still wet, grade the modelling of the body, and take out the highlights with a tissue. Build up the modelling of the form in increasingly darker colours, either in washes, or in a method used in eighteenth-century France, that appears to anticipate Impressionism. This was to add form to the figure by tiny dots of colour (Fig. 89) and shadow that increase in density and depth as the tone gets darker. Otherwise, you could build up the basic tones of the form of the body, and add the flesh colour in a wash over the tone drawing. It is not too difficult to develop a formula for painting the nude that looks effective, but in the end any formula is self defeating. It is a great test of a water colour artist to be able to paint a really serious study of the nude figure, and it is always worth trying.

Fig. 89. Here, form is made by dots of paint with a very fine brush. The deeper the hollow, or the sharper the turn; the closer dots are painted

PORTRAITS IN WATER COLOUR

In the same way as water colour is so suitable for the fleeting effects of landscape, it is similarly admirably suitable for the fleeting effects of expression in portraiture. Perhaps the painter who most succeeded in this aspect of water colour was Ambrose McEvoy the English painter who died in 1927 at a sadly young age. Try to see his work whenever you have the chance, at sales or galleries. His water colours were obviously influenced by John Singer Sargent whose water colour group portraits we will consider later. The great secret of a water colour nude or portrait is *not* to make a coloured pencil drawing. Make as little drawing as you possibly can with the pencil. Indeed, try to get into the habit of starting the drawing for the painting in brush first. As in a figure painting, you can either paint on wet or dry paper. If you like smooth paint, rather like miniature painting then you should use a hot-pressed paper. By working on dry rough surfaced wove paper you can drag the brush across the paper to get an effect that looks rather like chalk. By working on to a ground of wet pale flesh colour you can blend in the colours of the cheeks and the main features.

There are many ways of using water colour for portraits as you can see, and to begin, you should attempt them all. If you are the sort of painter whose first try always works when attempting portraits, but as you work into the painting it loses its freshness, then portraits in water colour are for you. Water colour portraits are inclined to lose their fresh-

140

Fig. 90. Quick, accurate brush strokes for the fleeting expression. Practise drawing the head in water colour

ness if they are overworked. Children are an ideal subject for water colour, as they have very fleeting moods and therefore expressions that affect their whole bodies.

Figs. 34–42 will give you some guide to building up a portrait. However much you are concerned with the fleeting expression (Fig. 90) you cannot ignore the structure underneath. Always remember that the eyes, nose and mouth are only a small part of the mass of the head.

WATER COLOUR AS DRAWING

There is the aspect of water colour that is to all intents and purposes drawing. This is when you work with only brown or black with water and brush and pen. This has inexhaustible possibilities in painting the figure or the portrait. It is possible to build up an intense tone study of the figure or the head. The one rule applies that you are obliged to start pale and work up to dark. The main areas can be laid in with a pale wash of sepia or black, and the more detailed work drawn in with a pen in wash. The painters who worked in this way are so many that the best thing is for you to seek some out for yourself. Of those one could name, most conspicuous are Rembrandt, Rubens, Guercino and Tiepolo. The technique of monochrome wash leads into the next

subject of figure compositions. Monochrome water colour was the medium by which many painters first planned out their full scale compositions. Poussin is an artist who comes to mind in this context. Today, when we live in an age that has not produced the formal composition, I will not spend time on that, but it is worth a few words on water colour for group subjects.

WATER COLOURS FOR GROUPS AND FIGURES

If one carries a water colour box and sketch book, one can make a record of the most delightful subjects. Bathers, picnickers, games etc. Sargent's water colours are the most enchanting records of boating and outdoor activities.

Another case where a water colour is so good is for giving permanent form to the fleeting effect of light. One of the main problems of painting figures out of doors in the sunlight is that it is difficult to tell form, light and colour apart, proving in fact that these are all dependent on each other.

A very good way of getting immediate unity between figures and their surroundings is to paint the main shapes in first with a single colour, blue or green or what you will, and this will give immediate unity to the painting. Indeed, you could lay in the main areas of shape with the same colour as you will do the shadows, so the painting has a oneness to start with, before you begin. This is the way Poussin effected his marvellous water colour sketches for compositions (Fig. 91). These were of course intended for full scale oil compositions. Supposing, for a moment, you wanted to use your water colours as a step towards an oil or an acrylic. The answer then is to make several sketches of the same subject, and then work from them in the studio.

To return to water colour for its own sake. Think of the endless possibilities of taking your water colours on any agreeable occasion, bathing, perhaps, or in the country. Quickly in a few lines and colours you will have a record of the brightness of sun and colours of nature. It is one of the pleasantest of sounds and sensations, the feel and splash of a brush in water. To be practical: Remember that scale of figures in relation to their surroundings gives authenticity to your sketch. Just as it was pointed out that figures give scale to buildings, so similarly see trees, fences, building sites in relation to figures. If you are doing sketches of figures in

Fig. 91. Bathing group in landscape

action toward a full scale composition, you may find it easier
to use only sepia and wash.

Generally as regards treatment of the figure in traditional
water colour, you cannot expect to get the intensity that you
would in oil and acrylic. Once you start with this assump-
tion, and accept the limitations as an advantage, then you
are not disappointed when the paint will not do what is not
in its nature. To begin, often one is disappointed by the
results of one's work. You then have to ask yourself if you
were not expecting the paint itself to behave in a different
way. As one becomes more experienced, one learns to know
in advance more or less how the paint itself will look. Then
one's eye will become more in tune with one's hand and one's
mind.

The figure in water colour was painted by Rodin, and also
by his close disciple and friend, Gwen John. Among other
painters are Manet and Renoir.

Many Victorian painters painted portraits in water
colour, as did Ambrose McEvoy and John Singer Sargent.

Among living artists there are William Roberts R.A.,
Maurice Feild, Patrick Procktor, John Ward R.A.

At all times one should study the old masters' drawings. It
is an insight into the working of their minds. Therefore, of

the artists who did water colour sketches of figures in groups, you cannot have enough of looking at:

Rembrandt, 1606–69 Poussin, 1593–1665
Delacroix, 1798–1863 Cézanne, 1839–1906
 Rubens, 1577–1640

ARCHITECTURE – AND BOATS

The division of subjects under the title headings is for the convenience of the beginner. Of course there are times enough where the divisions intersect – landscape will contain buildings, and ships cannot usually be considered without water. There are certain subjects like figure painting and architecture, that in some approaches demand rules. Special types of architectural painting need a knowledge of anatomy from which to look at the figure. These rules are not necessary to every painter; it depends on the sort of artist you are. Whatever sort of painting you do; there are the constant and timeless qualities of oneness, tonality and relevant information which apply to any painting, so any approach to a subject should contain these elements.

To begin, we could look at the techniques and methods of traditional architectural studies. If the idea is too daunting, go on to the next bit of the book if you like, though, it is quite possible to read in one subject something that you findthrows light on something else! Some of the finest architectural studies in water colour were those made by Paul Sandby and the young Turner. They appeal to us to this day for their clarity of drawing, not only in the linear drawing but in the tonal design. These water colours were made to be turned into etchings and engravings which accounts for their directness, and the giving and communicating of information to the onlooker.

Even before we begin, we had better consider what perspective is about. As a student, I found perspective difficult beyond the most simple exercises. For this reason, I shall be lamentably inadequate at explaining it now to the long suffering reader! I console myself that it is possible to make do with guessing as long as it looks right in the picture! Naturally a great deal of painting from nature and the external world is about the same idea. Something may be true in your eye and mind, or to the rule, but it does not work in the painting. This is one of the most fascinating problems in painting from nature. But to return to perspective, Figs 92

and 93 will give you some basic rules to go on with, and the book list at the end of the chapter will advise you further.

In formal architectural studies, there will be without question the problem of drawing in the subject before you start to paint. Even before this, there is the matter of the kind of paper. The smoother, thinner paper is better for taking the drawing. For paper with a slight 'tooth', Barcham Greens 'Bockingford' 70 lb. is very suitable. This is a mould-made paper. Of other mould-made papers from Barcham Green, the 68 Royal Hot Pressed, 72 lb. Imperial, is excellent. If you want a hand-made paper, there is Barcham Green's R.W.S. Imperial 90 lb. All these papers are wove papers. If like Sandby, you prefer to paint on a laid paper, white, or cream Ingres papers are readily obtainable at any artists' colourman. Probably, you will not want to paint as large as Imperial or Royal so the paper can be slit in half. It gives a nicer looking edge if the paper is slit with a knife, rather than cutting it with scissors. A harder, rather than softer, pencil is recommended for drawing in the subject, for the obvious reason that soft pencil is easily dissolved in the colour and water, and the painting becomes messy and depressing when you have barely begun.

Easier written than painted, but *do* try to get your first lines on the paper sure and accurate. If this is daunting for your first efforts, make trial drawings of the subject. You can train your hand in practising drawing buildings of any kinds on ordinary paper. When it comes to starting your water colour on the paper stretched and ready, where reasonably possible, do not rely on rubbing out. Rubbers are ruinous to the surface of even the best papers. By the time you have made exploratory drawings the idea of your painting should be clear in your mind to be transferred to the paper.

While you are drawing, rest your hand on a piece of paper to keep the surface of the water colour paper clean. Insistence on cleanliness of equipment is not stressed for the sake of being fussy. The clear white of the paper on its own, or its reflection through transparent colour, is basic to good water colour. Out of perversity, one *could* find water colours that would contradict this. But any painting where the vision of the artist is so great that respect of materials does not matter, are so few that one can afford to ignore them as examples.

① The first simple rule of thumb

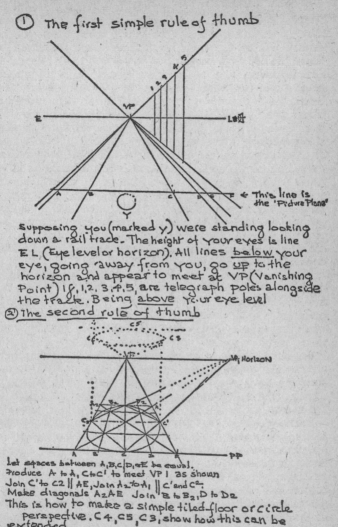

Supposing you (marked Y) were standing looking down a rail track. The height of your eyes is line E L (Eye level or horizon). All lines <u>below</u> your eye, going away from you, go <u>up</u> to the horizon and appear to meet at VP (Vanishing Point) 1£, 1,2. 3,4,5, are telegraph poles alongside the track. Being <u>above</u> your eye level

② The second rule of thumb

Let spaces between A,B,C,D,&E be equal.
Produce A to A, C to C' to meet VP 1 as shown
Join C' to C2 ∥ AE, Join A₂ to A₁ ∥ C' and C².
Make diagonals A₂ A E Join B to B₂, D to D₂
This is how to make a simple tiled floor or circle
 perspective. C4, C5, C3, show how this can be
extended

Fig. 92. Perspective

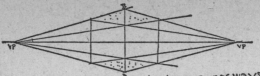

H though you are looking corner ways on at line AB, there will be two vanishing points.

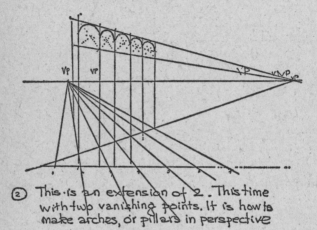

② This is an extension of 2. This time with two vanishing points. It is how to make arches, or pillars in perspective

Perspective continued

So back to your drawing. It is exceedingly likely when one looks at the very elaborate architectural water colours of Turner, that he drew in much of the detail away from the subject. It is fairly obvious what is meant by 'detail' in architecture (Fig. 94). While you are drawing on the spot, concentrate on proportions of the large areas. Keep the drawing clear, and do not be tempted to add cross hatchings or any sort of tones with the pencil. The drawing prepared, colour should now be added. Depending on how much time you have to finish (and there may not be much), indicate in patches of paint the main colours, so that you have enough information to finish from memory. If you have plenty of time you can do all the colouring on the spot. The basic rule for traditional water colour painting applies equally well to architectural studies. That is, apply the palest colours first,

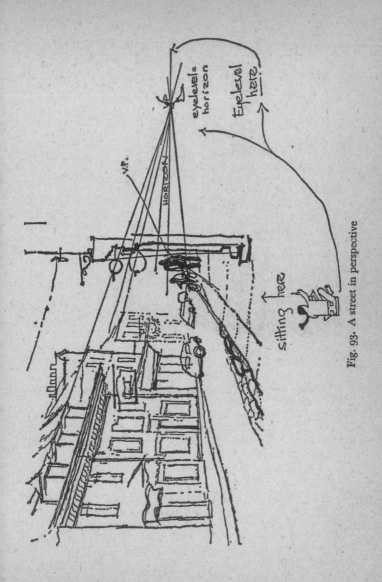

Fig. 93. A street in perspective

149

Fig. 94. Ken Howard R.O.I. A.R.C.A. who specialises in paintings of
architecture, has done this drawing of architectural detail of ornament

working up the the darkest – though Paul Sandby laid in the
tones first in sepia, adding colour later. You can use tone
very agreeably to make not only distance and form but as
pattern and composition (Fig. 95). Architectural studies
come quite naturally and easily to some painters. If they
present difficulties to you, and yet you feel they are really
what you want to do, be assured that they can be mastered

Fig. 95. Tones to make patterns

by practice. If by ill luck you have struggled on and the
result is hopeless, as with any other painting, never get
discouraged. You have always gained something, even
unconsciously. Architectural studies are particularly suitable
to a limited palette. With a very few colours you can get a
wide range of mixed colours. If you want to try this, here is
a suitable list:

Monestial or Winsor blue
Yellow ochre
Light red
Raw umber

The Monestial blue (or Winsor blue) can be mixed with
the light red to a wide variety of greys, both warm and cold.

The early water colours of architectural views were painted
when cathedral cities still had the architectural unity they
must have had in the Middle Ages. Cathedrals and churches
were not dwarfed by tower blocks. Sometimes it is rather
tempting to leave out modern developments. This must be
your decision, though I always like to put in the vigorous
horizontals and verticals of modern buildings (Fig. 96). In
fact, these horizontals and verticals are very useful for
measurement of everything else in the painting.

To do the illustrations for this chapter, I went into St
James's Park with the worthy intention of drawing the
beautiful views of the Houses of Parliament and Westminster

Fig. 96. The vigorous verticals and horizontals of modern building. Modern building has its proportions too. Look for how the facades are broken up in areas of windows, tiles, storeys etc. – See Fig. 57 too

Abbey from the park. It is a lovely view (Fig. 97). Especially when the trees are bare, as they seem to be in the same terms as the architecture of the Abbey. I freely admit it was all too much to take in, and like many great views it over-whelms one. In the end out of a sort of reaction I found I was drawing the pigeons on the paving stones! This is a long way round of saying that drawing in architectural surroundings need not be the obvious view, sometimes the most spectacular view of a place is a work of art already, done for you by the architect as it were. A chance sight can give you as much, and more, of the atmosphere of a place. This same point was made in relation to all the other aspects of water colour, because of the suitability of water colour for this sort of approach. Think of it – if you lived in a big city, you could take to work a small water colour block, and, almost every day paint something in your lunch hour. Working in a city the chances are one never ever sees the famous sights! My water colours of London seem all to be of pigeons (though Venice, Paris, and Bucharest – to name just three – have those as well), street traders, sweet shops and parked cars (Fig. 98). This is all very personal, and there is really only one instruction to give here: be on the alert for something that you feel that you particularly

A view of St. James's London

with some pigeons too

Fig. 97. Don't always take the obvious view!

associate with the place at which you are looking.

At first, it appears that twentieth-century architecture is isolated from the architecture of the past. Of course, in many ways it is. It is concerned with the new materials and their methods of production, prefabrication, etc. The most striking thing about modern architecture is the dramatic horizontals and verticals, and glittering glass. Seeing some of those glass structures, it is difficult not to want to try to

The street cries, the stalls, little shops That are also the landscape of a city –

Fig. 98. Observe, observe, observe!

capture this in water colour. The one thing that all architecture has in common is proportion. A beautiful building of any age depends on the proportion of its parts to the whole. Whatever architecture you are drawing and then painting, look for the relationships of the masses one to another. This will also help you in good composition. Some modern architecture will remind you of the elegant proportions of the paintings of Ben Nicholson, or Moholy-Nagy.

Not seeing relationships of this kind is the most usual thing that goes wrong with architectural studies. As in a figure – and indeed in the Renaissance architecture was inseparable

from painting and sculpture – some persons have a natural eye for proportion. Either way, it is a very good idea to get into the way of measuring. Always remember, too, to think about the amount of space you leave around an architectural drawing. This can create scale. If you paint a modern building with not enough space, the whole concept of scale is destroyed. It is very easy to get carried away in architecture by the detail, especially in fine old Georgian buildings. One should of course be interested in detail, but always see that the tones are in keeping, and that as you paint them they do not tonally jump out at you. If you do get some paint on that is too dark, washing it out with a very water laden brush is inclined to take off colour where you do not want it to. You can always try blotting it out at once with tissue, though – as cannot be repeated enough – mistakes in traditional water colour are better prevented than cured! Chapter 13 tells in more detail how, if something has gone wrong with a traditional water colour, but for some reason you still want to go on, you can draw over the painting in pen and ink. The tonality of the ink, which is much darker, will put the other tones into keeping again.

On the subject of blotting out, you can use this in traditional water colour to make a very agreeable texture resembling the crumbliness of stone and brick. The most obvious way of giving scale to architectural painting is to include figures. Anything built to live and work in is, in its widest interpretation, architecture. We have discussed fine buildings, and the atmosphere of places. But do not forget that a very real and valid expression of architecture is in the vernacular. This is architecture of the farm house, cottage (Fig. 99), terraced house in cities, and many dwelling houses. They are not formally designed by architects or master builders. They grow up as the need demands. They are the buildings that we first draw. We should still respond to them. As in some of the subjects mentioned in the chapter on landscape it is a world in front of your nose. A house and its garden or a cottage and its flowers used to be very popular subjects for water colour. If you like painting them you need not worry too much about perspective, but you should still bear in mind the fact of colours in tones in keeping.

Boats and ships of all kinds have the same appeal as architecture. You can learn to paint boats by sets of rules, and observation of proportion. Remember, though, that

Fig. 99. The cottage

however much you obey rules, the end result may not 'look' right in the painting. Turner with just the flick of a brush makes a mark in the context of the painting that reads as a boat.

Boats and architecture, like many man-made things, on no account have to be painted literally and accurately, if you would rather not do so. They can be used as almost abstract *motifs* for compositions without losing their basic identity. If the idea of experimenting with *motifs* of this kind inspires you, it is possible to make many attractive and useful experiments with colour tone and shape. Here are some suggestions:

A townscape in a limited palette. Perhaps only using earth colours or only tones. Or using particular colours to evoke a certain mood. Blue perhaps to suggest evening and melancholy.

Using washes of colour to suggest boats in full sail, rushing by. Boats seem to have an absolutely basic appeal to most people and many painters. Some painters, like John Ward R.A., paint intricate and most beautiful studies in water colour of boats, all details accurately painted. Perhaps we might respond to the patterns of masts and ropes. Then there is Van Gogh's marvellous water colour of the bright little fishing boats. Maybe the drawing is not meticulous but the gaiety and vitality of the little boats delight us even eighty years after the picture was painted. Look at boats when next you see them and try to sum up in your painting what we respond to in them. Is it the primal shape? Or the delight of being in water? Or speed? As many people, if you can judge by exhibitions, respond to boats and ships (Fig. 100)

Fig. 100. Little boats – a popular subject. See illustration 54 as well.

as they do to flowers. Sometimes we feel that if a thing is painted repeatedly there is little point in painting it again. On the contrary, the more a subject is painted provides proof that this visual image is common to all of us, and always worth, if not repeating, at any rate reinterpreting in your own way.

To effect speed: use quick, bold brush strokes. You should leave plenty of white spaces on the paper to effect the sparkle of waves and sails. Think about what colours will make the mood of the painting. And on this subject here is a list of some colours you can mix. For buildings.

Yellow ochre + raw umber = a sandstone colour.

Yellow ochre + violet = a neutral.

Orange + a touch of violet = an unusual stone colour.

Some greys that are useful for stone, buildings, water, ships, sky:

Cobalt blue + light red.

Ultramarine + light red.

Violet + raw umber.

These are all warm colours. The only way to obtain a really cold and forbidding grey is with black and water, and some blue.

The classic masters of architectural studies: Paul Sandby, the young Turner and Tom Girtin were all active in the late eighteenth and early nineteenth centuries, Later there was J. S. Cotman, W. Callow, T. Shotter Boys, Samuel Prout. As ever try and see originals when you can. However good a reproduction, you do not get the sense of the actual texture of the paper, at all times part of the essential

character of water colour. These mentioned are the best known among many fine artists and paintings to be seen. In our own times there is John Piper, Edward Bawden R.A.

Do not think that, by advocating in speed of working in this chapter, I countenance carelessness. A great water colour combines speed with accuracy. This accuracy can only come by continual work and observation. A quick, immediate brush stroke can be just as well observed as the most painstaking detail. Details of structure are one of the delights of painting fine sailing boats and great ships. For practical purposes, if the intensity of details of this kind are what interest you most, the drawing is best done in the studio. You can paint from the spot to get the correct light and colours. Naturally enough, a more spontaneous water colour can, and should, be done on the spot. It is quite a difficult question as to just how much, in painting from nature, you should actually do on the site. Some painters are capable of retaining the freshness of the original in their mind's eye, and others find that, after a time, nature becomes too much, too confusing. The danger of working on a water colour in the studio is that of overworking the surface, and losing the spontaneity which is the true delight of the medium. However, if highly wrought detail appeals to you, then you must paint in your way.

To begin, try all kinds of approaches to painting – attempt everything between the highly finished and the direct. It is the only way to discover what is the way of painting that is yours. For detailed painting, you should use very fine sable brushes. If you like painting abstracts with a strong figurative content, then you can choose whether to paint on the spot or in the studio. Some painters draw from nature first and abstract from the drawings. One rather suspects that the beautiful semi-abstract water colours of Paul Klee were done entirely in the studio, without any drawings from nature first.

RECOMMENDED READING
Chevin's *Perspective*, published by Studio Vista.

FLOWERS IN WATER COLOUR

Anyone familiar with nineteenth-century novels will know the stock character of the painting master. The impoverished painter who taught young ladies to paint flowers is one of Thackeray's favourites. These painters are comic figures, but I wonder how many of us would secretly rather like to learn to paint flowers from a teacher thoroughly trained in the traditional methods. Young women then learnt to paint flowers for the excellent reasons that they are pretty and give pleasure. The clarity and delicacy of water colour makes the medium admirably suited to flowers. As well as decoration, flowers and plants were the subjects in the eighteenth and nineteenth centures of the most magnificent botanical studies. Of course, botanical studies date back to the beginning of time, but I am thinking of water colour.

As direct botanical studies are such an excellent training in drawing, why not start by doing one. Like the life study, it is one of those areas of drawing where whatever the outcome one will have learnt something. Botanical drawings were not primarily intended as works of art; they became works of art from their directness and accuracy. Looking at a good botanical study, a trained person should be able to tell, even if they had never seen the plant before, exactly what family of plant they belong to. The artist should be able to see the general characteristics of a plant.

To begin then: for a beginner, a pot plant that will keep the same for quite a few sessions without dropping is essential. Paint flowers when you are a bit more experienced. A hot pressed paper, or an Ingres is a good surface. If the thought of attempting a new subject on very good paper is daunting, then a quality cartridge paper will do as well. The plant should be placed in an even light. Do not think of holding it in your hand, this is a nuisance and will distract you! Keep twigs, flowers, etc. in a jar of water. You should try and look at the plant from its most characteristic angle. It should be drawn as near life size as possible. If it is much larger or smaller than life, it never looks quite right. Before

you begin, make some small sketches of the shape and the pattern of the plant. It is worth considering botanical structure (Fig. 101). Making the plant an agreeable arrangement on the page need not distort its accuracy. When you come to draw on your final piece of paper, rest your hand on another piece of paper to keep the drawing sheet clean. Draw the plant in hard pencil. Keep to clear cut lines and do not attempt to shade or cross hatch.

When you come to paint, the rule is, as with any other water colour, start with the palest colours and work up to the darkest. If needs be for unusually coloured flowers, enlarge your palette with more colours. For white flowers you should leave, as in any other water colour, the spaces of the paper, painting only the shadows and veins. If you really become addicted to botanical flower painting (and why not) to obtain practice, start at first with simple plants and gradually go on to the more complicated ones. Of course, in this way an artist is like a scientist; it is his job to simplify the complexity of nature. In a paradoxical way, the more complex the flower, the more easy it is to see its structure, once you are accustomed to looking (Fig. 102). Botanical drawings, of course, can also include birds, caterpillars and butterflies in their natural habitat. It spoils any sort of natural study to make anything up. If you paint a botanical study (Fig. 103), do not (I was going to write) make up butterflies and birds, but it occurs to me that if you really want to and it will give pleasure to somebody else, then go ahead. In general, however, it is not advisable. One of the greatest difficulties in plant drawing is effecting a balance between the clear, direct strokes of colour and detail. It is all too easy to have a painting that is detailed but not accurate. A plant study at the early stages – that is, in the lighter stages of the painting – should be painted as broadly as possible. As in any other painting, the detail should be tonally in keeping with the whole. While detail is only relevant to when it connects to the whole growth of the plant, relevant detail is essential to good plant studies. There is no need to try to make plants look beautiful. If you paint them truthfully they become works of art by direct transcription. (Lord Clark said this, rightly, about a snowy landscape – anything shown up against snow looks like a clear and excellent drawing.)

A very good idea, when you are painting flowers or plants

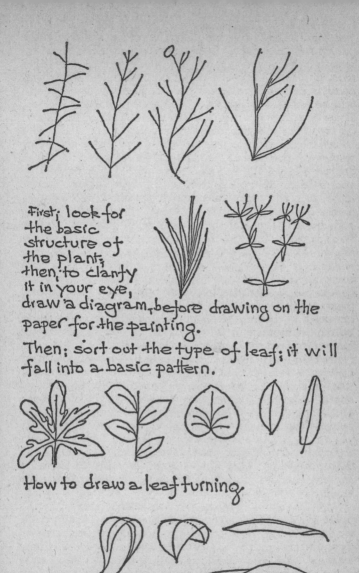

First, look for
the basic
structure of
the plant,
then, to clarify
it in your eye,
draw a diagram, before drawing on the
paper for the painting.

Then, sort out the type of leaf; it will
fall into a basic pattern.

How to draw a leaf turning

Fig. 101. Plant structure

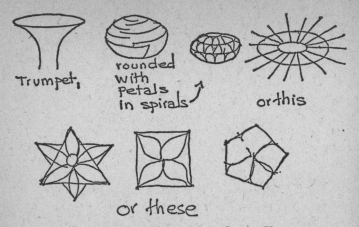

Fig. 102. Look now for the solid form of the flowers. Here are some
general shapes

is, once you have found the correct colour for anything you
need, to mix up a really substantial quality. Keep it so that
you can use it another time, as even if it dries it can, of
course, be dissolved again. Plant drawing demonstrates the
very close relationship – which cannot be emphasised
enough – between drawing and design. Plants you will find,
fall into a series of basic patterns. Naturally, there are very
fine painters who cannot, or do not like to, paint plant
studies. If it does happen that you do not like doing them,
no need to worry. You have learned something and it is
always worth trying everything. However much one may
actually think one might take to a sort of painting, one
cannot know till one has tried. The results can be surprising
and unexpected. Even if they disappoint, there is one cure,
go on to the next, quickly before you start worrying too
much!

The first part of this chapter stressed plant drawing as a
branch of scientific drawing, and the discipline this imposes.
You only have to look at the many beautiful water colours of
flowers to see that most artists respond perhaps more spon-
taneously to flowers. It is easy, in some ways, to get a sort of
effect of flowers by staining the paper in shapes of colours,
this is the very opposite approach to the botanical studies
we have examined earlier. You can let yourself go, really

162

Fig. 103. A plant drawing, with the intention of putting botanical accuracy before everything else

enjoying the splashing about with the colour in the water. Parts can be blotted out with tissue, and over them you can put another colour wash.

In this way of painting flowers you do not have to paint the flowers literally (Fig. 104), you are painting the atmosphere and sense of flowers. You can mix up large luminous amounts of colour and freely apply it with a big brush. If the paper is damp, you can let the paint soak into the paper,

Fig. 104. Some flower paintings do not intend to be accurate. They try to give the feeling of flowers. Flowers have suggested shapes and colours to the painter

and each stain of paint run into each other slightly. These are not only the two extremes of flower painting, they are also the two extremes of water colour painting. The hard clear edged type and the soft, melted edge (Fig. 105). To return to flowers, there is nothing against producing imaginative flower paintings indefinitely if it gives you satisfaction, but I rather think that unless you discipline your hand and

Fig. 105. A soft melted edge and a clear hard edge

Fig. 106. For flowers against the light leave white spaces round each form

eye sometimes with some exercises in accuracy, the paintings may easily get worse rather than better. Most paintings fall between these opposite approaches. They are both considered and spontaneous. One of the most attractive aspects of water colour is painting flowers against the light. Have you ever seen flowers in a window with the light coming through them (Fig. 106) and wished you could paint them? It is not too difficult. The usual rules for water colour apply, of course – you should have enough clean water, and not mix your colours too much or this will stop the light reflecting

Fig. 107. The formal flower still life

through the paper. You must, of course, start light and build up darker. After this, there is one rather unusual way of handling your paint, which was given as an exercise in Chapter 8. This is, to remind you, painting areas of colour and shape divided one from another by the line left by the white of the paper. This really does give the idea of light shining through the objects. You do not have to use this technique in all of the painting, only where you feel you most need it. It also suggests using dry paper. This means that the paper can be left to dry after stretching or if the sheet is not too large, it need not be stretched and soaked at all.

So far, the approaches to flower painting have been formal, either botanical studies or flowers in vases. As in still life the problems of composition are in general formal. It is particularly tempting in water colour to think only of the flowers and ignore the background; very often because of the delicacy of water colour it does not matter if you do not paint backgrounds all too elaborately. Remember in water colour the paper in its whiteness and surface is as im-

Fig. 108. The chance handful left on the table

portant as the paint itself. Divisions in any subject matter are
for general convenience. Vases of flowers could just as well
have come under the heading of still life (Fig. 107), not only
from the formal point of approach, but from the fact that
many artists think of the beautiful and sensual colours of fruit
in the same context. Just as in the chapter on still life we
looked at the entirely informal approach to still life, the
same applies to flowers. Have you ever tried to make a flower
arrangement with great care, only to find that the handful
left on the table (Fig. 108) looks prettier? This is an example
of the informal for which water colour is so suitable. It is
rather like looking through an imposing old-fashioned book
with steel engravings, only to find that little vignettes at the
end of each chapter tell you something just as valuable! The
occasions where one can use informal water colour, as I look
at some rough notes on the subject, are, on second thoughts
possibly somewhat commonplace. Sometimes, though, the
commonplace is still worth stating – the line between the
commonplace and the fundamental is so very fine.

To return to the subject of the informal water colour: a
branch of blossom against a sky rather as in a Chinese or
Japanese painting; flowers growing out of a wall, or by a
fence, or in window boxes all lined up (Fig. 109). I hope you
will think of many more for you yourself. You will find when
it actually comes to painting any subject just seen at a

167

plants on a sill

Blossoms on a branch

plants growing out of a wall

Fig. 109. Informal compositions

glance, that you will have to arrange it on the paper. Sometimes one arranges the objects by trimming the paper, which is very easy to do in water colour, but do beware of getting into the bad habit of trimming so much that you never have anything left!

You may like to have a list of permanent colours for increasing your palette for flower painting. There are some very dainty colours, that for preference should not be mixed, as they might get 'lost'. They are cobalt violet, cobalt

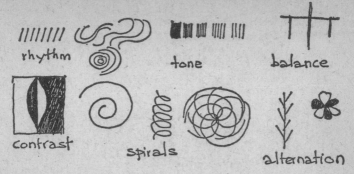

Fig. 110. The basics of composition

green, genuine rose madder, and, if you have not got it on your palette already, permanent rose. You may like to try Winsor and Newton's olive green which is a permanent warm green. If you are painting in water colour the small intimate sketches mentioned above, you need not work on very large paper, and once it is not much bigger than eight by nine inches, it scarcely needs stretching. If you are treating water colour as an aspect of still life, the paper will probably be much larger, and you will be well advised to stretch it properly on a board before you begin. Once you are starting any water colour which has any formal content, it is a good idea to work out some designs before you begin on the water colour paper. Fig. 110 demonstrates the basic ideas of composition – tonality, balance, contrast, rhythm. Rhythm is a primal cause in nature, and plant life has many kinds of rhythm: the spiral, alternation, etc.

Of books to read, there are many delightful anthologies and picture books of flowers with reproductions of flower paintings of all periods and artists. These books are designed for the sole purpose of giving pleasure, and should be looked at for this reason. Several books and folios are available on Pierre Redouté, most famous for his beautiful rose paintings. While they are in themselves sources of great delight, they also should be studied with great care for the purpose for which they were intended, botanical studies. A classic work on botanical illustration is:

The Art of Botanical Illustration by Wilfrid Blunt.

Some great botanical illustrators are:

George Ehret 1708–70, R. J. Thornton 1768–1837, Alfred Parsons 1847–1920. One must not forget two classics of plant painting; Albrecht Dürer's *Great Clump of Grass* and *Violets*.

Now for a list of painters to look out for, though always remember the unknowns as well, whom you should try and seek out for yourself in museums, private galleries, antique shops and local exhibitions.

Emil Nolde painted a magnificent series of flowers in water colour. Look out also for those of Bonnard, John Nash, Maxwell Armfield, Patrick Procktor and John Ward.

A good textbook of biology with diagrams of plants is as useful a way as any to study the anatomy of plants. If trees can come under the heading of plants then there is:

Artistic Anatomy of Trees, by R. Vicat Cole published now in paperback by the Dover publishing company.

For general and inspiring reading:

Growth and Form by D'Arcy Thomson, Cambridge Paper Back.

VARIATIONS ON WATER COLOUR TECHNIQUE

The next two chapters are concerned with variations on the technique of water colour. The order of chapters does not necessarily mean you should practise traditional methods before the variations. You can start water colour painting from here. However, if there is a question of preference, it may be that traditional water colour is an excellent discipline for clarifying one's ideas. It is more difficult to go from the variations of water colour technique to traditional, than the other way about.

The most obvious approach to water colour is tinting an ink drawing. Of course, you have to use water-proof inks. First there is:

Indian Ink. It is dense black, waterproof and dries almost immediately. Once you have made any mark with Indian ink you cannot remove it. Indian ink can be used with any kind of steel pen or quill pen. Reed pens are inclined to get clogged up with Indian ink. This can happen with any pen in time, so it is advisable to wipe pens thoroughly after use. Never leave the top off bottles of Indian ink longer than you need as it will dry out quickly. Fig. 111 will show the kind of marks you can make with pen. Indian ink can be used with great effect with brush. In this case you must be certain to rinse and clean brushes. Indian ink quickly ruins brushes so it is as well to have two sets of brushes, one for Indian ink only. For this, you can make do perfectly well with rather cheaper brushes. Whatever sort of mark you make with Indian ink, it will be darker than any paint, even black. This will mean you have a very clear drawing line to guide your areas of colour.

Another very useful method for Indian ink is in the following; if a water colour goes wrong, and tones and colours get all out of key, you can do some drastic, and effective redrawing in Indian ink. A smoother surface paper takes a pen line best, especially Ingres paper. Though with rough surface wove paper you can drag the brush with ink

Thin, fine marks with a Mapping Pen

Thick/Thin marks with
the usual steel nib –

This mark was made
with the wrong end of
the pen!

INK

Fig. 111. Pen marks with Indian ink

over the surface, it looks rather like a chalk mark if you do
so. You can draw on paper with Indian ink: and then stretch
the paper or soak it, and the ink will not be moved. Some
artists like to stretch and wet the paper and draw a fine line
into it when the paper is still wet. The line will run slightly
into the paper with furry edges, rather agreeable to look at.

172

This is a technique often used by that master of line and water colour, Paul Klee.

Indian ink can be diluted to paler tones, but it is scarcely worth it as they are not a fine wash. Indian inks are permanent. Many artists probably could not face the prospect of an architectural study without drawing it out in Indian ink first. Indian ink is sometimes known as Mapping ink, as one of its main uses is for mapping. The very fine mapping pens are admirable for very detailed botanical and architectural drawings. Make quite certain to keep your mapping pens clean. All pens should be rinsed in water and wiped dry on cotton or linen. Other fabrics have annoying hairs that get into nibs. Do not try actually mixing water colour with any ink. It makes a horrible and quite unproductive mess!

You have probably seen very bright clear inks for artists; these are Mandarin inks.

Mandarin Inks are dyes dissolved in distilled water and in shellac. They are entirely waterproof and cannot be dissolved in plain water, only in distilled water. The shellac makes these inks very shiny and bright. Mandarin inks come in a variety of brilliant colours. Their brilliance could make water colours seem dull by comparison. Though the browns and neutrals are agreeable and effective for preliminary drawing to water colour. A rather amusing, but extravagant experiment is to soak a piece of paper and drop coloured Mandarin ink on to the wet surface. It floats about rather like petrol on wet pavements. Mandarin inks dry very quickly and are inclined to encrust pen nibs.

Despite the brilliance of Mandarin inks, unfortunately they are not entirely permanent, and any work done in them should be kept from continual exposure to light. You cannot work with Mandarin ink into damp paper with a pen as it will not take. If you are not concerned too much about permanence, Mandarin inks are a great delight. They can be glazed on top of each other, and the effect can be quite like enamelled jewellery. If you are painting with Mandarin inks, they can easily stick to the brush; be certain that you clean brushes in distilled water. If you have a steam iron you probably have distilled water at home. These inks take very well on the hard, bright surface of fashion boards.

Drawing with pen and water colour. A useful variant of pen and ink drawing is to make up large quantities of water colour in water, either directly from the tube or pan, or

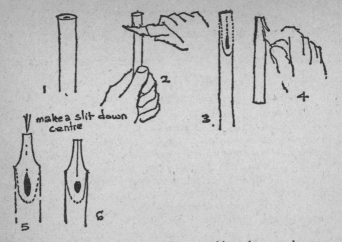

make a slit down centre

Fig. 112. This is how to cut your own pens with reeds, or garden canes

mixed. Paint can then be used with a pen to draw in colour. You can use steel pens, quill pens or reed pens. You can cut your own reed pens, or use garden canes which are just as good. Fig. 112 will show you how. A reed or cane pen makes a thick, vigorous line, and they were much used by Van Gogh. Drawing with paint is particularly pleasing for plant drawing or architectural studies. You can draw out a subject before you begin in this technique. The conventional colours for preliminary drawing are the neutral greys and brown, and, you can mix some delightful ones all your own in water colour. They will not be anything like as strong as ink. I find it very accurate to natural colours to draw with water colour in brilliant blues, yellows and reds before painting.

You cannot, of course, draw in paint and then stretch the paper as the paint will wash away; so you have to draw into paper that is either stretched already or is not intended to be stretched. The technique of pen and water colour is equally useful for drawing into a finished water colour. I have used this method on some occasions to make texture for its own sake, and to increase the intricacy of detail, as in tree trunks and plants. This technique works slightly better on a smooth or laid paper, than on heavy wove with a texture. The classic English water colour painters like David Cox and Cotman would never have used pen and ink or

174

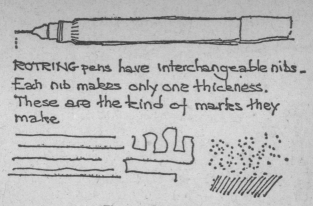

ROTRING pens have interchangeable nibs. Each nib makes only one thickness. These are the kind of marks they make

Fig. 113. Rotring pen

pen and paint with water colour, but two equally fine and original talents, Francis Towne and Edward Lear, did and also Samuel Palmer.

Rotring Pens are illustrated in Fig. 113. They are very useful for carrying about and can make an unusually lively line, or dots.

Resist Techniques. Some materials resist water. If water colour is applied to them the water rolls of the surface. So, if you make marks with wax crayon on paper, and then paint

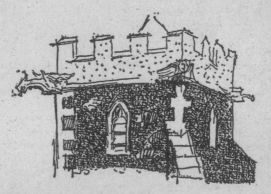

Fig. 114. The tone gives some idea of the crumbly texture you can get by painting water colour over wax crayon

on top, the paint will not 'take' where the wax is. Wax in its turn will not mark on wet paper. Ordinary wax crayons are perfectly suitable for this purpose. Any colour can be used. Black and white wax crayons are particularly effective for making unusual darks and highlights. You will notice that even on the smoothest paper wax crayon makes crumbly marks (Fig. 114).

Study some of the water colours of John Piper, who uses this technique to brilliant effect in his architectural studies. Some artists use single white candle wax, which is also nearly transparent. This means resist techniques can be taken even further.

You can paint any colour, lemon yellow for example, and wait till it is dry. Then rub transparent wax over some of it, and wash over a red or ultramarine. You will then get a textured and unusual orange or green. Naturally, you can use this technique with any other colours. Try painting an abstract pattern entirely in resist technique.

Oil Pastels, which come in brilliant colours, also resist water colour. There is one warning about coloured wax crayons or oil pastels. They have not been in use long enough to say whether the colours are permanent and non-fading.

The resist technique was very popular in the nineteen-forties and fifties with some of the so-called English Neo-Romantics: John Piper, Graham Sutherland, Keith Vaughan and the late John Minton. In many cases these painters used Indian ink for the drawing.

Chinese Brushes are generally available in most art shops. You will find that they all come to a point at the top of a cone. Perhaps delightful Chinese paintings have inspired you to try one. I have to admit that my own efforts have not had anything like the elegance and wit of the Chinese artists; who seem to have the ability in their very bodies! It is still worth trying a Chinese brush if you want to. Always remember that in the West we are inclined to handle a brush in the same way as we write. In China, as you may know, writing is much nearer to drawing So, taking a look at the Chinese paintbrush again, you will see that it has to be used on its tip. At first, practise brush strokes making sure how you are holding the brush. Then have a look at Fig. 115. It is taken from a Chinese manual on how to use your brush. You can use Chinese ink, or plain black, or sepia water colour. Any other colours can of course be used

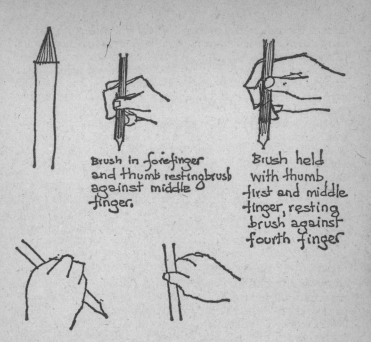

Brush in forefinger and thumb resting brush against middle finger.

Brush held with thumb, first and middle finger, resting brush against fourth finger

Fig. 115. How to hold a Chinese paintbrush in the Eastern way

too. By tradition the black on white is most usual and most effective.

For painters whose work you should look at, we have mentioned Edward Lear, Francis Towne and Samuel Palmer. More into modern times there is Segonzac, John Piper, John Ward, R. A. John Minton, Henry Moore's 'Shelter' drawings, and indeed many many others. Naturally, you should seek some out for yourself in your local museum and galleries. Books and magazines often have excellent pen and water colour illustrations with a wide variety of techniques. A classic of this is *The Forsyte Saga* illustrated by Anthony Gross. For pure pen drawing as illustration, then the list would be endless. Once you see a kind of technique in a magazine that you like the look of, always cut it out to keep for reference or for copying.

Two great illustrators of the past were Edmund Dulac and Beatrix Potter.

SOME MORE VARIATIONS, TINTED PAPER AND GOUACHE

So far discussion has been biased toward the use of white paper, in itself part of the art of water colour as it shines through the transparent colour. Chapter 7 describes some of the tinted papers that are readily available. There are the heavy wove papers like Turner's blue, and another aptly named 'porridge' paper. You can use these papers dry surfaced before or after stretching. If you use them dry, the paintbrush will make a crumbly line rather like chalk marks. When you use them wet, the colour will soak into the surface and spread better. I have seen a study in black by Turner on the paper of his name, done on a dry surface.

The whole thinking of water colour on tinted paper has to be around the idea that there is no white contained in the paper. So, the tonality of the painting has to be lowered. Some of the tinted Ingres and Tumba papers are quite low in tone to start with, and so you will be obliged to think in very low key. An Ingres or Tumba paper will have to be stretched as they are quite thin. These papers can be used to great effect to paint subjects that in themselves are sombre in key (Fig. 116), like David Cox's stormy skies, and evening studies. An Ingres or Tumba paper is laid with a smooth surface and, the brush marks will, in consequence, be smoother. A heavy wove paper like porridge or Turner blue is far more suitable for heavy washes, as when you are painting a very cloudy sky, or a stormy sea.

If you feel the painting needs white to set off the other tones then you should add a touch of Chinese white, either plain or tinted with another colour. This can be used to delightful effect in night scenes. White could be used on a dark tinted paper to paint a moon to show up the dark of the rest. Once you start adding a white, or some high pitched colour to a dark tinted paper, then you should use the natural colour of the paper to make the middle tones. The effect of adding white or tinted white can also be used to show lit up evening windows in a townscape. Turner

In a water colour
on tinted paper
the tonality is
lowered.

This illustration
gives an idea of
how to highlight
a dark toned
water colour
with gouache. The
contrast can be
very effective.

Fig. 116. Tinted paper and gouache

himself has used this method most movingly in mountain scapes to highlight the snow. There is a water colour on tinted paper by Whistler where a touch of pink makes a sunset.

It is possible, while gouache is wet, to make a texture in it. This is done in most cases with the wrong end of the brush! When you are adding paint mixed with Chinese white to a traditional water colour, you are not only using contrast of tone, you are using contrast of density, as of course white is opaque. Another use for *Chinese white in water colour* is where a traditional water colour may have gone wrong, and for some reason you do not want to start all over again: you can then do some repainting in water colour gouache.

True traditional water colourists would deplore this mixing of media, though if the end result is a good painting then there cannot be any harm. Edward Bawden R.A. quite deliberately uses this technique in architectural studies. I stress deliberately, because the use of gouache in traditional water colour can easily get out of control and you will end up with a gouache and no water colour at all. This would be a pity if you were using a beautiful tinted paper where the

colour of the paper is part of the painting. I have often bought tinted Ingres and Tumba paper just because the colours appealed to me, and the colour of the paper suggested a painting. Often enough it has been flowers, though you may think of other things. A flower study on a tinted ground is very attractive.

In the event that you wanted a gouache anyway, some more had better be said about it. Most people are familiar with poster paint which is really a kind of gouache. It is the paint most of us had our most elementary lessons in painting in. You can use designers' gouache, or poster paint or water colour mixed with Chinese white. For the latter you could use student colours, which are entirely permanent. If you are occasionally using Chinese white with water colour that you use traditionally, you must take care to remove all trace of Chinese white from the colours after use.

A very attractive way of using water colour gouache is on coloured paper, using the tint of the paper to effect a middle tone, so that you get the quality of the paper with the quality of the paint too. This method is admirable for abstraction or figurative work. It is true that there is a kind of abstraction that is very near to figurative painting, indeed deriving from it. There are things in the external world of which we have pre-knowledge. You can turn them into all kinds of shapes and patterns without them losing their identity. Now, consider for a moment some of the delightful still life paintings by Braque, where he uses a middle tone to give line and quality to the parts of the painting. You could also in figurative painting decide whether the colour of the paper were warm or cold, and use this to great advantage in figures and shadows on buildings. Using gouache like this, you can get many ideas by looking at some of the delightful lithographs of Bonnard and Vuillard. On the subject of Bonnard, he uses a mixture of water colour and gouache to great advantage in most of his water colours.

Designers' gouache and poster paint. A basic palette has been given in Chapter 7. Always remember that these paints dry a tone *lighter* than they appear when they are wet. This is particularly noticeable in the darkest colours. All colours will dry to a fairly narrow range of tonality. This means that it is not difficult to have the painting in keeping.

A painting in poster or gouache will dry with a matt surface. You can use any paper type support including

Fig. 117. Supposing these stripes were the colours described. Would you see the complementary colours between the stripes?

cardboard. You can use hardboard primed with acrylic emulsion, though this is seldom used and not really worth the trouble.

Poster paint is very convenient. You can paint over your mistakes. Unlike polymer or acrylic paints, the paint can be dissolved in water again if it has dried on the brush. If you are inclined to paint in a high key, poster paint is very suitable. I have seen paintings in a high key that have almost the effect of ancient mural paintings. As you do not get the full quality of dark colours, poster and designers' gouache are not as suitable for painting in a dark key. Poster and designers' paints cannot be used to build up thick masses; if you try then the colour will crack. As these paints dry with a matt surface you can work over the top with chalk or pastels. *Not* the other way about, working wet paint into chalk or pastel, or you will get a most disagreeable mess.

Thin paper is not very suitable for poster and designers' gouache. One does see in artists' colourmen matt-surfaced papers sold specially labelled poster paper. This probably implies advertising, as the colours are very bright indeed. I find them not easy to use for painting pictures, but if the gay colours inspire you, then go ahead! The brightness is not permanent, so be warned. On the subject of permanence, this is a warning if you are experimenting with fluorescent colours; they are fun, but they fade. You can, though, make some profitable experiments with fluorescent colours. Here then are some to try with the theory of complementary colours (Fig. 117).

On a white piece of paper, paint stripes very evenly in fluorescent green. Do the spaces left out take on a pinkish tint? On a piece of paper which is painted fluorescent yellow, paint on top of that squares in pale grey. Do they now veer to purple? Exercises apart, you can use fluorescent

colours for fun, and get the most gay results. Though be warned, they are impermanent.

Some more about designers' colours and poster paint. Designers' colours are specially manufactured to be opaque, as it is assumed that they are used for colour reproduction. This, to an extent, is the same in poster colours. Hence both kinds of paint are not really suitable for glazing effects. Indeed you cannot rely on ever getting any transparency in gouache. This is not necessarily a disadvantage. Whatever kind of paint you are employing should be used within its own terms. Paradoxically, when you find that any kind of paint will *not* do certain things, you can use this limitation to give the whole character to your use of the medium. Try and see that pots of poster paint and any gouache do not dry out. They can be dissolved again in water, but they lose the agreeable syrupy quality that they have at their best. Because of the very density of gouache, mixtures can soon get muddy. If this happens, then start again. This is why it is quite a good idea in gouache to have a larger number of colours, not mixing unless it is necessary. If you are painting directly from nature you will have to rely on the colours drying a tone lighter.

You will often find that gouache looks very chalky, and this has to be used to advantage. Make certain when you are using gouache to have plenty of clean water. The very nature of gouache, I find, makes its use better for stylised design work than direct painting from nature; though this is only a personal opinion and you may feel quite differently. Flesh colours are notoriously difficult in gouache, as it is very difficult to get the subtlety of the flesh's transparent quality. The formulae for mixing flesh are the same as in any other colours: a base of white, with yellow ochre and light red. It is when you come to shadows or glazes that the difficulties arise. One of the most important things in beginning to paint is learning to use each medium according to what it can do. Never try to force it beyond these limits, and always enjoy the medium for its own sake. Most of the artists who paint in gouache tend to the design rather than direct painting from nature. The medium has been generally popular in the twentieth century.

For examples of all aspects of gouache, for water colour painters who quite conspicuously use gouache with traditional water colour but also with great restraint and discre-

tion, one can name Raoul Dufy, John Minton, Turner, Bonnard. Living today and showing at the Royal Academy is Edward Bawden R.A.

A very good way of seeing good use of gouache is in advertisements and magazine illustration; some of the techniques are amazingly skilful. Notice how a really skilled illustrator in gouache has a way of dragging a paint-laden brush across the surface of the paper to make the paint look like chalk. This is done by using dry paint in a dry brush. If you particularly like some kind of technique you should cut out any illustration or advertisement from a magazine and keep it for reference.

FRAMING AND EXHIBITING

Modern experimental painting needs no frame as such. However, if you see one plain and then see one with the simplest metal strip round it, you will be amazed at the difference. Figurative paintings in acrylic look better in frames too. A frame has a way of isolating a painting from its surroundings and concentrating your vision on it. This is particularly true of a traditional water colour. They can very easily get lost without a good frame and well-cut mount. Gouache should be framed and mounted too.

A good frame may easily make all the difference when the work has to hold its own with lots of other paintings before a selection committee. Good frames are, admittedly, expensive. Many painters have a few very good standard-sized frames and work to this same standard size. For gouache and traditional water colours, you can get very attractive tinted mounts to set off the colours in the painting. Take care in choosing size of mount.

Storing. No paintings should ever be stored in a damp place, especially traditional water colour. This also applies to water colour paper.

Hanging. Even with the finest rag paper and permanent colours, it is not entirely advisable to hang water colour in direct strong light. Water colours should be glazed. As well as framed,

Exhibiting. The idea is a bit alarming at first. It is disheartening if one's work is rejected; though the chances are that your work was a borderline case, not that it was so bad that it was thrown out by an indignant hanging committee. Sometimes it can make one feel worse if one's work is hung. It is on the wall horribly laid bare to every stray comment! Yet seeing your work hung among other people's, and having to hold its own, is a very good way of assessing it afresh.

There are national exhibitions devoted to water colour only. These are: Royal Institute of Painters in Water Colour, Britain in Water Colours, and Royal Society of Painters in

Water Colour. Very local exhibitions will be advertised in the local paper and public library.

All national exhibitions or regional exhibitions will be advertised in a very useful magazine *Arts Review* published by Gainsborough Periodicals. The sending-in date and place is advertised well in advance. All public and private galleries in the British Isles advertise in *Arts Review*. This excellent publication is published fortnightly. Another very good publication is *The Artist*. If you are not already familiar with it, it contains many practical articles on how to paint and sculpt in a large variety of media by many artists. Art clubs and summer schools advertise in this magazine, which is published monthly. The same magazine runs a very useful question answering service.

In every locality there is an art club, art school, or evening institute where you can attend classes. I imagine you will certainly want to, as you cannot learn everything out of books. Classes are a very good way of getting into the way of working regularly.

Copying. Another very good way of learning is by copying paintings whose technique, or other qualities, particularly appeal to you. It is almost like a painting lesson from the artist himself. If the idea of copying is not agreeable to you, do not worry. You will be in the very good company of Hogarth who deplored the idea! For all that, a useful copy does not have to be a replica. You would start off with the basic idea of somebody else's painting and reinterpret it, even in a different medium. Perhaps copy a coloured picture in its tones, or in different colours. I freely admit to being addicted to copying, and hence I am biased in its favour. It is a very good way of getting to know a favourite painting thoroughly. In fact anything that increases and inspires your work is good. Every artist you can think of collects reproductions of his favourite paintings. Some artists collect shells or stones for their colours, and other natural objects and chance finds, like dried leaves and grasses; these are very good to paint. Beautiful scraps of old woven textiles are very inspiring, not only for their design and colour but also for their texture.

Photographs can be very stimulating. Do not misunderstand me however. This does not mean (unless again you want it to) copying in paint a photograph, or forcing the paint to imitate the chemical and glossy surface of a photograph.

Some of the beautiful modern photographs in colour supplements and magazines can be inspiring for their colour harmonies and originality. A photograph can suggest a new way of looking at a long familiar sight, from a different angle or composition. Sometimes they can, in themselves, be used as visual evidence. Chapter 6 mentioned subjects that you may not always have the opportunity to paint directly. Do not forget the collages in Chapter 2; cut up photographs are delightful in this context. Indeed, photographs can as much inspire the abstract painter as the figurative. Once you are setting about collecting photographs as helpful to your work, you could set about collecting other things.

Worth looking out for in antique shops. With luck, you may occasionally, in browsing through files of water colours, find some unused old hand-made paper. I turned up some fine David Cox paper once, which is alas now ro longer made. Second-hand bookshops sometimes have water colour manuals now out of print, perhaps very old. They can be a bit disappointing as they are on papers no longer in production and in colours that are out of use; yet their vision of nature in itself can be inspiring.

Take care of your work and date it, so that you can see if you are getting better, or want to refer to your work again.

SAVING MONEY

Often enough I have heard people voice worries about the cost of painting. When one questions them further it nearly always transpires that they *are* spending too much money, but on the wrong things! Here is a list of things you should never attempt to save on: in traditional water colour, never try to economise on brushes, paint and paper. You may well ask what is there left to spend money on? The answer to this is that it is possible to waste money on amusing gadgets like water holders and manufactured palettes. If you are doing preliminary sketches and drawings for water colour, you can use as cheap a paper as you like. You can save money on rubbers by simply not buying them at all!

In acrylic, you can save money by using hardboard and not canvas supports; also by taking the greatest care to rinse your brushes *continually*, so that you do not spoil them by letting the paint dry solid on them. You can save on acrylic paint by *always* remembering to put the caps back on the

tubes when you have put paint out. In acrylic you can paint over old pictures if you feel they are not worth keeping. For that matter, you can use the backs of water colours if the paper is clean and thick enough.

A word of warning, however: do leave your work a year or so before working over it or destroying it. One can so easily get fed up with a painting as soon as it is finished, that one's instinct is to throw it away at once! Obviously, if you were to do this you would end up with no work at all. When you come back to your work after a period of time it may, on second thoughts, be worth keeping, or some more painting into.

SELLING WORK

Always be prepared to sell your work. Look round any exhibition at which you are showing, and work out a price from other pictures that are more or less the same size as your own, and in the same medium. I find that people even seem to *prefer* pictures they have paid for!

PLANNING WORK

I find it helpful to plan a general programme of work. It should be flexible, especially if you are dependent on going out to paint. A timetable has a way of prodding your conscience and making you get on with it!

Regular work cannot be sufficiently emphasised. The most dedicated artist will tell you that it is very easy to put off working to do something else 'more important'. Once you have started to work, however, you will be surprised how quickly the mood to paint will come. Perhaps not many of us have the good fortune to have a room they can use entirely as a studio. If you have, this makes working easier, as you can at least shut yourself away, and if work is not going too well, no one need see it! The next best thing is some corner of a room that you can establish as *yours*, so that you will always know where your equipment is, when you start work after the last time. I hope the equipment will be clean from the previous session! I have emphasised this point rather a lot too. Perhaps on reading this book you have thought I have repeated the same points time and time again. It is because of their basic importance one does this. What painting is about can be said in comparatively few words. It is how you interpret them that makes you a painter

in your way. The purpose of any teaching or handbook is to help *you* paint pictures that are about *you* and *your* interpretation of the universe around you, and the person you are, in yourself. In an earlier chapter – the one on flowers – I mentioned that some things sounded perhaps a little hackneyed and commonplace. Paradoxically, this is the very reason for repeating them. Many people question whether painting can ever 'do any good'. The fact that people paint – like gardening, sewing or decorating the house as you like – raises the general quality of life. It is something that does good to the next generation. Maybe, however, the answer in the end as to why one does, or should, paint is much simpler; it is because one has the particular talents bestowed on one.

To get back to practicalities. A few words about the classifications 'Amateur' and 'Professional' may not be out of place. Actually, where possible I have tried to avoid them, but a point did come up in an art club. An entirely dedicated student was trying to paint on very cheap wood-chip paper with about three colours. When I questioned this, the answer was 'I'm only an amateur'. In some ways this is genuinely humble and right, but it does not give your work a chance. I am certain no one would skimp on materials in other recreations and hobbies. If you think about it, there are many so-called professional artists who have no more time to paint, hour for hour, than many so-called amateurs, perhaps less. It is their attitude that may be different. From now on it will be as well I think to drop these annoying classifications and whoever you are, concentrate on doing your best with the painting that is in hand.

All a book can do is to start you off and make some things easy. The serious difficulties have to be tackled as they are met. In any case, you may disagree with everything in the book. A valuable part of learning is rejecting what is no longer of use to you. Old-style art teachers always used to recommend students to carry a small sketch book to take down anything that caught their eye at odd moments – faces, buildings, etc. This is a very good idea as it trains your eye to see, and makes your seeing eye more acute and observant. We are trained at a very early age to read, to such an extent that we even read a painting from left to right. Few of us are taught to see until much later. In our schooldays much more of learning comes through reading. We become

conditioned to the written word. It becomes a habit, when we see things, to put a word to them, rather than a shape or colour. When you start to look, and to use your eyes without describing in words in your mind, you will be amazed at the things in front of you that you never noticed before. A sketch book will train your hand to work at, one with, and indistinguishably from, your eye and mind.

The Artist and Arts Review have already been mentioned. Other publications that are worth reading for articles on art history are The Burlington Magazine, Apollo and The Connoisseur. Contemporary art is fully documented in Art International, Studio and Art and Artist. A very good idea is to collect a scrap book. It has been recommended in Chapter 13 as a means of collecting paintings and drawings that are useful to you. A scrap book can, and should, be used to collect writings on art or anything else that you find inspiring. This thought leads us into the next chapter. As you will see I am ending the book with quotations from other painters.

WORDS OF WISDOM

The previous chapter advised you to keep a personal scrap book of favourite quotations. The following are all taken from water colour painters, or painters who used water colours. Of course, poems and quotations found by chance can be inspiring too, but these are so personal you will have to find them for yourself.

Alexander Cozens, 1717–86:
'Unity of character is true simplicity.'
'To blot is to make varied spots and shapes with ink on paper, producing accidental form without lines, from which ideas are presented to the mind.'

From the Reverend Gilpin's treatise on the Picturesque in 1792:
'From correct knowledge of objects arises another amusement; that of representing by a few strokes in a sketch, those ideas which have made most impression on us. A few scratches like a short hand scrawl of our own, legible at least to ourselves, will serve to raise in our minds remembrance of the beauties they humbly represent.'

David Cox writing in 1813:
'The picture should be perfect and complete in the mind before it is traced on the paper.'
'When the pupil has made a correct and decided outline all timidity vanishes.'
'The pupil will also find his progress greatly accelerated by the dedication of his leisure moments to the copying object of still life.'
'In the selection of a subject from nature the student should ever keep in view the principal object that induced him to make the sketch.'
'The light aerial tints should be laid on the remotest parts of the picture, gradually brightening into more rich and decided tones as they approach the nearer and more

prominent objects, taking care to preserve the same atmosphere throughout the picture.'

'Light and shade effects should first be studies in Indian ink and sepia, by which clearer conceptions of each will be acquired.'

'He who devotes his time to the construction of the perfect outline, when he has gained this point, he has more than half finished his piece.'

'Every tint should be laid on with clearness and decision, so that the object may receive its proper tone at first touch of the brush.'

'Thus, a cottage or pretty village scene, requires a soft and simple admixture of tones calculated to produce pleasure without astonishment, awakening delightful sensations without touching on the nobler province of feeling.'

When you study the water colours of David Cox, and there are many to be found in art galleries and museums, you will see why so much space has been given to him.

John Constable wrote in a letter in 1822:
'It will be difficult to name a class of landscape in which the sky is not the chief organ of sentiment, the standard of scale and keynote.'

'I never saw an ugly thing in my life.'

John Varley wrote in 1816:
'Painting in oil and water colour have their peculiar advantages, in those qualities which are different to each other, texture is one of the great excellencies of oil painting. Clear skies and water are the beauties most sought after in water colours.'

'The playful variety of sunlight is of infinite use in helping to break a long line of monotonous buildings.'

Aaron Penley writing in a water colour manual of 1852:
'The great charm of water colour painting lies in the beauty and truthfulness of its aerial tones.'

'Breadth is a quality in art consisting of a just combination of large masses of light or shadow. Boldness is essential, but that boldness must be accompanied by prudence and discretion.'

About the same time as the above words of very good advice from Penley were written, Eugene Delacroix (1798–1863) in France wrote:

'The particular charm of water colour, besides which oil paint seems brownish yellow lie in its continuous transparency. In water colour one must strike exactly right, no correction is possible.'

'An amended sky is a failure. Since the white of the paper is reserved for clouds the contour must be right from the start.'

Here are a couple of second-hand accounts of two very great painters in water colour, J. M. W. Turner (1775–1851) and Tom Girtin (1775–1802).

Ruskin described Turner's method of working in one passage. He wrote that Turner 'laid in the broad masses in broad tints; while they were still wet he brought out the soft lights with the point of a brush, and sometimes he scratched out the highlights.'

Turner is reported to have said of his great contemporary, Tom Girtin, that 'if Girtin had lived he would have starved!' By all accounts Girtin 'laid on his skies first, they were always remarkably luminous. Some times he used warm tinted paper. He so mixed his greys, that by using them judiciously, they served to represent every species of subject.'

Water colour was particularly suitable to the Impressionists' theory. Water colour did not appear to have the tradition of rules of procedure in France as it had in Britain. Indeed, until the Impressionists and post Impressionists, it was not associate with French painting to anything like the extent we associate it with British painting. The freshness and quality of light that we associate with water colour made it very appropriate to these painters. Alas, not all of them have written or commented directly on water colour, but where they have, they are quoted:

Cézanne wrote in about 1904:

'It is all a question of getting as much unity as possible.'

Signac (1863–1935) wrote:

'A cloudy sky is a magnificent composition. But it changes continuously. Speed of execution and limitation of size will also prevent the artist from laborious detail that would deaden his vision ... the watercolourist misses nothing, recording everything which brings life and interest to the main *motif*.'

Raoul Dufy (*1877–1953*):
 'The passages between the colours are themselves formed by the white of the paper.'

Emil Nolde (*1867–1956*): A German Expressionist
 'Flowers bloom to give people joy, I paint them in summer and prolong the joy into winter.'

Bonnard (*1867–1947*):
 'When I tried to paint the bunch of roses, I let myself become involved in it, I let myself drift into painting the roses.'

Paul Klee (*1879–1940*): A German Surrealist
 'We must not precipitate anything but let it ripen.'
 'But there is no one rule – everyone must go where his heart leads him.'

This is Klee describing a walk in the country in terms of painting everything he sees:
 'All kinds of different lines. Blobs of colour. Stippling. Stippled and striped surfaces. Undulatory movement. Broken articulated movement. Counter movement. Objects interlaced and interwoven. Masonry, peeling stone, line losing itself, gaining strength.'
 'More important than nature and its study is the ability to concentrate on the contents of one's own box of colours.'

Contemporary with the French painters of the first three decades of this century, are some very excellent British painters. Here are some of their remarks on water colour.

Lamorna Birch (*1869–1955*) wrote:
 'Be brave, use plenty of water. Do not be afraid of using a good strong dark while the paper is wet; do not niggle, get as much expression as you possibly can out of each brushful.'

Sir George Clausen (*1852–1940*) wrote:
 'I try to put the colour on in one wash, without retouching, for I think that there is nothing so beautiful as clean tint in water colour that is exactly right. Even if it does not aim exactly into the right place (for water colour is

tricky) the quality of the colour has something of the spontaneity and effortlessness that one finds in nature.'

Everyone is surely familiar with the astounding skill of the late Sir William Russell Flint's water colour. You will be interested to learn that he used, as well as sable brushes:
'one large hog hair brush for scrubbing out, and several flat hog hair brushes for lifting off paint.'
Water colour is still very popular, for as the writer *Henry Miller said:*
'Water colour grasps the essential rhythm, the bouquet, the perfume.'

Two living painters who use water colour have very generously allowed me to quote them.

Maurice Feild has written a passage specially for this chapter:
'Water colour means to me a wonderful moment in the early years of the nineteenth century, when the topographical drawing, the classical landscape, and the romantic spirit came together especially in the work of Turner, Girtin and Cotman. Although this moment can never be recaptured, I believe it is still possible for an artist to make a personal contribution to water colour today. The topographical drawing implies an interest in place, in the shapes of land and sea, some knowledge of trees, plants, animals and man-made towns, villages and country crafts, and individual buildings. The classical landscape adds to the organisation of the picture space, both on the flat and in depth, while the romantic spirit yields a more subjective approach, influenced more by light and the weather in creating images in the mind which correspond to a wide range of emotions, from the peace of a still clear morning to the drama of a thunder storm. Water colour can be used in each of these ways, but it is when they come together that the aesthetic thrill penetrates the whole of one's being. It is this experience that makes the painting of water colours seem difficult, but artists who are aware, who practise long enough, accepting failure, will achieve this. Good luck to them!'

The Editor of the London Magazine, *Alan Ross and the painter-author, Patrick Procktor have with great kindness, let me quote*

Patrick Procktor's article 'A Return to Water Colour' from Volume 7 No. 9, 1967:

'Water colour, though translucent, is like the stain method in acrylic paint in one respect, that is in having no body. The body is in the forms. Water colour paper, of course, is non-porous and, without sinking, the particles of colour lie in little pits lit from behind by the white paper, offering themselves directly to the eye with no barriers between (no impasto, no trailing hand, no varnish, etc.). See how burnt sienna and ultramarine war and separate as they dry – it is a small miracle, like a huge Olitsky in microcosm, a marvellous malachite or pointillist happening for elves.

'The mention of flat paint brings me to some flat assertions, so to speak, without brush marks, extracts from a never-to-be written manual of instruction in a nonexistent library never to be borrowed by spectral amateurs of the art.

'Water colour is ideal for the rendering of atmosphere light, distant landscape effects of all kinds and views. Water colour is hard to use on a large scale. Water colour is hard to use geometrically. Water colour is often brilliant but it does not dazzle so it has no appeal for those who want to make hard graphic or eye dazzling effects. . . . Not correcting in water colour means that it does not lend itself to the Nearer-to-thee school who achieve objectivity through the elimination of mistakes and subtraction of uncertainties. Cézanne's water colour method is the art of subtle certainties. The best modern water colours are Klee's. When a water colour has gone too dark nothing can make it lighter, it is like a night that has fallen with no prospect or possibility of a dawn.'

The last two quotations are from two of the greatest of all water colour painters. First William Blake, the poet, painter and visionary (1757–1827):

'Purple night and crimson morning and golden day descending through the clear changing atmosphere displayed green fields among the varying clouds like paradises stretched in the expanse.'

Then Albrecht Dürer (1471–1528):

'The artist should fill his spirit with much copying of

things seen. This is not an end in itself but is converted into artistic skill, which germinates, grows and bears fruit after its kind.'

Now it is up to you to do your own paintings . . .

INDEX

Guide to
Painting in Oils

BARBARA DORF

This original and helpful book is designed to help anyone starting oil painting to create pictures that are entirely their own. Rules that are given are only guides, and can be broken if the result is a good, individual painting.

Extensive information is given on the many aspects of oil painting materials and techniques. The many line illustrations and diagrams in the text make points clearer and easier to follow.

There is something here for everyone who wishes to paint, and oil painting is approached as something to give satisfaction and pleasure to both painter and onlooker.

Sphere

Guide to Coarse Fishing

ARTHUR E. HARDY

Whether you take up coarse fishing for sport, relaxation or pure pleasure, a good 'starter' book can go a long way to eliminating some of the guesswork, explain the mysteries of modern fishing tackle and spell out, in simple detail, the wide variety of baits, methods and other 'wrinkles' that could mean the difference between a blank day and a worthwhile catch.

This is such a book. The easy to follow text takes the novice step by step into the watery world of each species of coarse fish – how, when and where it feeds and the right tackle, baits and methods for its successful and most sporting capture.

Sphere

Guide to
Tropical Fish and Fish Tanks

REGINALD DUTTA

Techniques improve very rapidly in this thriving, fast
changing industry – aerators, filters, tanks, heating and
lighting are clear examples, and you need to be guided by
a man who really knows the field. This book is produced
from within the very heart of the industry; the author is
the Managing Director of London's oldest-established
tropical fish specialists. The book is written from the
customer's point of view. Its information and guidance will
save many a needless headache and useless expense, and
make your tank pleasant and pleasing.

Sphere

Guide to
Stamp Collecting

KENNETH W. ANTHONY

This lively, non-technical guide to one of the world's most popular hobbies is a personal impression of the many pleasures of stamp collecting, written by an enthusiast who has been collecting stamps since boyhood and has been writing about them for more than twenty years.

As well as giving helpful advice to those taking up stamp collecting for the first time, the author reviews the financial side of the hobby, and traces the path ahead from the haphazard accumulation of stamps to the more complex interests of advanced philately.

Other chapters refer to such matters as the many different kinds of stamps that can be collected, the lure of postmarks, and the appeal of collecting to a theme.

Sphere

Guide to
Rose Growing

CYRIL C. HARRIS

This book on roses is something different. It is an excellent
guide for both beginners and experienced gardeners, who
wish to grow and propagate good roses. It also provides
them with the underlying reasons for certain horticultural
practices, which should enable them to do the essential
chores with renewed zest. Perhaps strangely with such
beautiful things, wherever roses grow, controversies rage,
leading to confusion in the minds of present-day gardeners.
Even soil preferences, the preparation of rose beds, pruning
and other fundamentals are not exempt. An attempt is made
in these pages to solve these enigmas so that gardeners can
henceforth tend their roses with a fuller understanding.

The latest developments in rose growing are also discussed,
together with the problems and prevention of pests and
diseases in a book that is an invaluable aid to anyone seeking
to cultivate roses.

Sphere

Guide to Bridge

NORMAN SQUIRE

Norman Squire first played bridge for England in 1946 and for sixteen years was Competition Editor for *Bridge Magazine* where his problems and articles 'contributed more original and valuable thought to the game than has anyone else since the war', and his teaching there and in periodicals and newspapers throughout the world did much to modernise the methods of even the best players. His tournament record has been called outstanding and includes repeated wins of the major British Championships.

In this book he provides a clear and comprehensive guide that is aimed directly at reducing the labour of learning in a fashion that will appeal to anyone seeking to master the art of bridge.

Sphere

All Sphere Books are available at your bookshop or newsagent, or can be ordered from the following address: Sphere Books, Cash Sales Department, P.O. Box 11, Falmouth, Cornwall.

Please send cheque or postal order (no currency), and allow 19p for postage and packing for the first book plus 9p per copy for each additional book ordered up to a maximum charge of 73p in U.K.

Customers in Eire and B.F.P.O. please allow 19p for postage and packing for the first book plus 9p per copy for the next six books, thereafter 3p per book.

Overseas customers please allow 20p for postage and packing for the first book and 10p per copy for each additional book.